Watercolor Basics: Drawing and Painting Birds

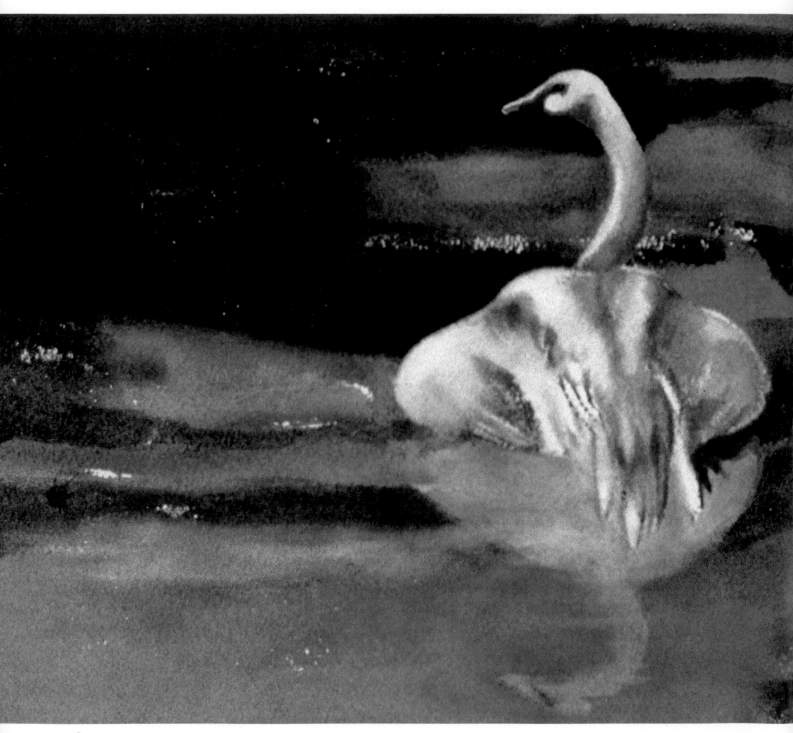

Swan
12″×16″ (30cm×41cm)

Watercolor Basics: Drawing and Painting Birds

SHIRLEY PORTER

NORTH LIGHT BOOKS
CINCINNATI, OHIO
www.nlbooks.com

ABOUT THE AUTHOR

Shirley Porter is a member of the American Watercolor Society, National Watercolor Society, Midwest Watercolor Society, Allied Artists of America and Audubon Artists. Her paintings have received numerous awards throughout her career and are featured in several books about painting. She has served as juror for many exhibitions. She has been painting birds in watercolor for more than twenty-five years, and with each year her love for both watercolor and birds continues to grow.

Watercolor Basics: Drawing and Painting Birds. Copyright © 2000 by Shirley Porter. Manufactured in China. All rights reserved. No part of this book may be reproduced in any form or by any electronic or mechanical means including information storage and retrieval systems without permission in writing from the publisher, except by a reviewer, who may quote brief passages in a review. Published by North Light Books, an imprint of F&W Publications, Inc., 1507 Dana Avenue, Cincinnati, Ohio 45207. (800) 289-0963. First edition.

Other fine North Light Books are available from your local bookstore, art supply store or direct from the publisher.

03 02 01 00 5 4 3 2 1

Library of Congress Cataloging-in-Publication Data

Porter, Shirley.
 Watercolor basics: drawing and painting birds / by Shirley Porter.—1st ed.
 p. cm.
 Includes index.
 ISBN 0-89134-919-7 (alk. paper)
 1. Birds in art. 2. Watercolor painting—Technique. I. Title.
ND2280 .P67 2000
751.42'24328—dc21

 99-39811
 CIP

Edited by Jennifer Lepore
Production edited by Nancy Pfister Lytle
Designed by Wendy Dunning
Production coordinated by Kristen Heller
Cover illustration by Shirley Porter

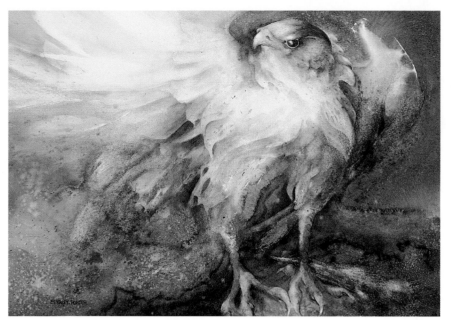

Old Eagle
14″×24″ (36cm×61cm)

ACKNOWLEDGMENTS

Rachel Wolf looked at my slides and rough notes and saw a book. Rachel is helpful, accessible, realistic and enthusiastic. She's a real delight to work with.

My editors, Jennifer Lepore and Nancy Lytle, gave me a sense of direction and helped keep me on track. Jennifer never panicked when I missed deadlines, but kept the faith. Nancy helped pull it all together so that the end result was indeed a book. Their suggestions and comments contributed greatly to the content and format of this book.

Jack Samit gave me more than encouragement. His friendship, support and generosity over many years made other things go more smoothly, enabling me to concentrate on painting and writing. He provided the kind of support that made it all work. Thanks Jack!

If not for Phil Metzger I might never have become a painter or written this book. He cleared the path and led the way in both endeavors. I've had many a fine adventure (and some interesting misadventures) following in his footsteps.

DEDICATION
To my sisters:

Eunice thought my childhood love for making pictures was important. She gave me my first brushes and paints.

Sue taught me by example that I could do whatever had to be done, if I set my mind to it.

You've both given me more than you know.

Gorgeous George
14″×24″ (36cm×61cm)

CONTENTS

INTRODUCTION

Birds were born (hatched?) to be painted. They come in all sizes and shapes. Their legs may be thick, thin, short or long. Their feet might show strong, prominent talons or be flat and webbed. There are delicate beaks, gigantic beaks, plain beaks and brightly decorated beaks. Birds not only wear every color imaginable, but every combination of colors, too. There are muted brown birds, glowing yellow birds and multicolored birds. Some birds appear very plain at a distance, but reveal beautifully patterned feathers up close. Many birds have special decorations on their heads, necks, bodies, tails, feet or wings. Feathers give the body texture, from the softest head feathers to the boldest wing or tail feathers. Additional texture is created as the feathers overlap.

The range of positions that any given bird can assume is almost limitless, so they can be maneuvered to fit a vast array of design needs. A bird can completely change its appearance by stretching a long neck to its full extent or folding it back close to the body. A flying bird looks entirely different from a sitting bird. Wings partially open give yet another outline.

Because birds are found everywhere, the background surrounding them can be almost anything—sky, foliage, land, ocean, stream and even cities. Diverse locations also mean there are birds to be watched and painted no matter where you are.

Birds exhibit attitudes from sinister to adorable, making them ideal for expressing emotion in a painting. A bird may cock his head, preen his feathers, lift a foot, hunch his shoulders, or even swivel his head while you are sketching. He wants to be certain that you get great painting material and are well entertained while you work!

A Basic Bird Source

Years ago, when I first began painting birds, I had many questions about how birds looked and behaved but was unable to find a clear, general source for the answers to those questions. I wanted to know how a wing folds. How are a bird's feathers arranged on his wings and body? How does a foot fit on a perch? Do legs have any feathers? How long are toes? And much, much more. Basic bird stuff. I watched birds a lot, as any painter should do. And took photos. And made drawings. But because birds constantly move and are usually some distance away, I couldn't get a close look and many of my questions remained unanswered. I began to look for similarities and differences from one bird to another and found this to be a valuable tool for identifying a particular bird in a painting. Searching bird watchers' guidebooks also proved very helpful because I could make leisurely observations and comparisons, which I could rarely do with a live bird. By using many sources and much time, I was able to find the answers I needed.

I would have loved to have had a single, simple source of basic bird information aimed at the artist—a source that gave me enough information to get started without overwhelming me; one that improved my *painting* of birds by improving my *observation* skills. In this book I've answered the questions I had as a beginner and have emphasized the importance of studying particular parts of a bird as a way of improving your paintings. I think these answers and observations will prove helpful to you, too.

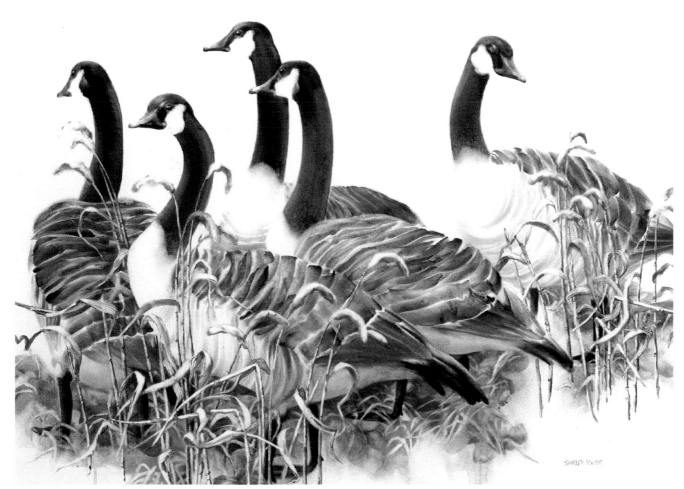

Canada Goose
20″ × 16″ (51cm × 41cm)

Winter Window
34″×24″ (86cm×61cm)

DRAWING BIRDS

A good drawing of a bird can be the first step toward a good painting. Drawing involves looking carefully and analyzing and interpreting what you see. Since birds move so quickly and so frequently, it's often hard to get a clear look at one. You need to take in information about his appearance at a fast pace. It helps to be armed with some basic knowledge about things that affect the way a bird looks. This way, you can spot important differences and similarities quickly, because you know what you're looking for. In chapter one we'll look at some distinctive bird features and how to make them a part of your drawings.

Drawing Supplies

Pencils

An ordinary no. 2 pencil works great for capturing the shape and attitude of a bird. A favorite of mine is a mechanical pencil made by Papermate. It has a soft touch on the paper and never grows dull, a real asset if you're working outdoors and have forgotten to take a sharpener. Just give the pencil a quick twist, and you're back in business.

I rarely use more than the one pencil, finding that simply varying the pressure with which I draw gives me a satisfactory range of values.

Erasers

I've often joked that if I couldn't erase, I couldn't draw. Erasers not only rid you of unwanted areas in your drawing, but are useful for adding texture and highlights. You can also lighten an area by dabbing into it with a kneaded eraser or reshape the eraser into a point or an edge to erase a fine, lighter area.

Like the kneaded eraser, an art gum eraser is good for removing light pencil marks without disturbing the paper surface.

A refillable eraser pen is one of my favorites for sharpening detail in small areas. The tip can be cut at an angle for erasing fine lines.

For larger areas, an ordinary eraser is handy. Choose a white one, as pink will stain the paper's surface.

The typing eraser is also great. It erases darker, more stubborn areas. But use it carefully, as it may damage the paper's surface.

I use all these erasers on my paintings, too. The softest lightens an area. The hardest, the typing eraser, actually removes the sizing and even some of the paper. A heavily erased area will absorb more paint and look different from the surrounding areas. Keep this in mind before using a hard eraser on a sheet of watercolor paper or an illustration board that you intend painting.

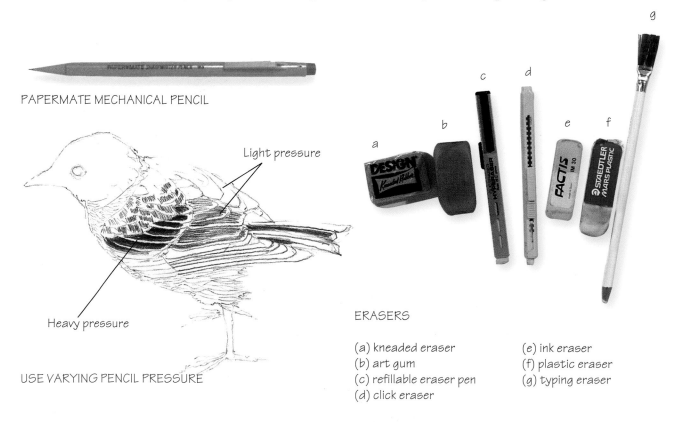

PAPERMATE MECHANICAL PENCIL

Light pressure

Heavy pressure

USE VARYING PENCIL PRESSURE

ERASERS

(a) kneaded eraser
(b) art gum
(c) refillable eraser pen
(d) click eraser

(e) ink eraser
(f) plastic eraser
(g) typing eraser

Paper

Some drawings are studies that you will use later for a painting, so you don't need to worry about the quality of the paper you use. Newsprint is fine. And if a drawing is to be transferred onto a painting surface, a lightweight paper such as newsprint is necessary. A heavy paper wouldn't allow the pressure from the pencil to pass through. I also like tracing vellum for drawings that are to be transferred to a painting surface. Discarded copier paper printed on only one side is great for studies—it's free and a good way to recycle. If the drawing is to be the final piece of work, then use a good quality paper such as a Bristol with some rag content. Bristol comes in two finishes or surface textures: vellum and plate. *Vellum* has a nice "tooth" (a somewhat broken surface) that takes the pencil well. A *plate* (extremely smooth) surface is also available. I don't like it as much as the vellum, however. Though its smoothness lends itself beautifully to fine detailing, the pencil marks sit almost totally on top of the paper surface and the drawing can be easily smeared, even while you're still working.

Accessories

When working on a drawing that you don't want smeared, it's a good idea to use a *hand rest* to protect the drawing from accidental contact with your hand. This rest also keeps your hand from tiring too quickly. I use a simple 4″ × 12″ (10cm × 30cm) Plexiglas strip raised from the paper by a 1″ (3cm) thick piece of wood fastened to each end.

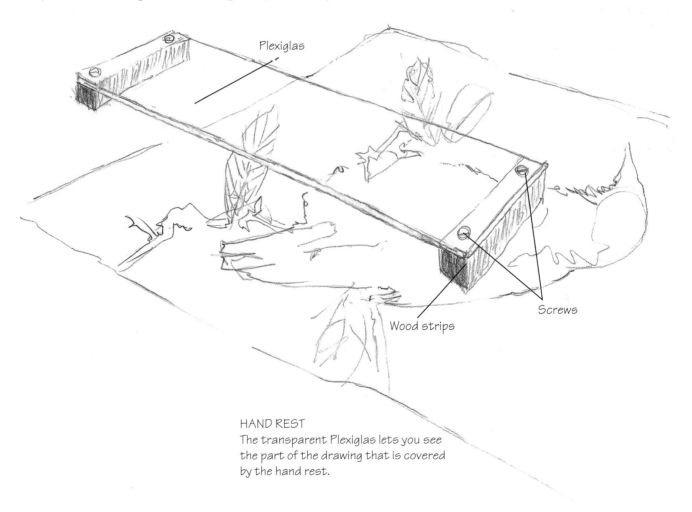

Plexiglas

Screws

Wood strips

HAND REST
The transparent Plexiglas lets you see the part of the drawing that is covered by the hand rest.

How Shape Is Related to Lifestyle

Shape

Shape is the first clue to the identity of a bird because you see more birds at a distance than close up. You can easily tell you are looking at a bird even if only the simplest shapes can be seen. When you see an animal with an oval body, a smaller oval head and a rectangular tail, you think "bird." Add a small cone-shaped bill to the round head and a couple of stick legs underneath and your vision says, "definitely a bird."

Identifying a Particular Bird

You can make a simple color identification—he's a "blue" bird, a "red" bird or a "black" bird. But if you want to know if this bird is an owl or an ostrich, a bluebird or a blue jay, look more carefully at the overall *shape* of the bird, paying attention to such distinguishing features as short or tall and thick or thin. Is the body rounded or oval? Is the breast pronounced?

Next look closely at the *detail* of individual body parts—how they are shaped and their proportions to other parts of the body. Is the tail wide or narrow? Long or short? Is the beak thick or long and slender? Does it end in a hook or a blunt spoonlike shape? Are the legs and feet thick and powerful or thin and delicate?

Extremely rare stickbird.

Lifestyle

Like other creatures, a bird is built to accommodate his lifestyle. A look at just a few water birds reveals that though they all live and feed in a water environment, the way they feed demands great differences in their basic construction. A bird that feeds while swimming has a different foot than a wader. A shallows wader has shorter legs than one that wades deeper to feed. A bird that catches fish has a very different beak than one whose food comes from filtering water through his beak. While it's not necessary to know a bird's habitat or what he eats in order to make a good drawing or painting, you'll find that becoming aware of these differences will help you capture the essence of your bird. The more you know about a bird, the more you see and remember when you observe and sketch. And when something in your drawing doesn't look right, it will be easier to identify the error.

Other factors such as mating rituals make important contributions to appearance, too. Just look at the peacock! It's important to remember that not all birds fit neatly into a generalization of "form follows function." But the majority do, giving you a good place to begin.

Categories

I have placed birds into seven groups according to their feeding preferences and habitat. These groups—perchers, waders, swimmers, divers, predators, insect catchers and tree trunk clingers—are based on *generalizations* about some birds that are familiar and are meant to help the beginner see similarities and differences in the appearance of various birds. They are not scientific classifications. For example, the group I call "perchers" includes Tyrannidae (flycatchers), Hirundinidae (swallows and martins), Paridae (chickadees and titmice) and many more. In this book, emphasis is on how the bird looks and some of the factors that influence his appearance.

Proportional Comparisons

You might say that the bald eagle's beak is large and broad in comparison to his head or that a crane has long legs. The eagle's beak-to-head proportion seems large because it is bigger than the beak of more commonly seen birds such as the house sparrow. The crane's legs look long because they're so different from those of a cardinal or starling. A bird is large or small only in comparison to another. His beak or legs are thick or long against the standard of some other bird. Usually the birds you are using as a basis for size, shape and detail comparisons are perching birds. Though many birds perch, I use the term perchers very loosely here to mean those familiar tree-sitters common to our yards, parks and woods.

Because so many perching birds (often called *songbirds*) are well known to us, they are a good measure for making observations about other, less familiar birds. Remember, however, that within any group, including perchers, there is also a lot of variation in shape, size and detail. Otherwise, all the birds in a group would look alike.

Keep the pine warbler and other perchers in mind as you look at the examples on pages 16–21 from other bird groups. Compare overall body shapes. Are they round or elongated? Look at leg lengths, beak thicknesses and neck lengths and widths. Some tails are short and blunt. Others are long and tapered. Wings may be broad or delicate, rounded or sharp. Each difference, whether large or small, helps distinguish one bird from another. Comparing the outline drawing to the detailed drawing will help you see the shape of each bird's body more clearly.

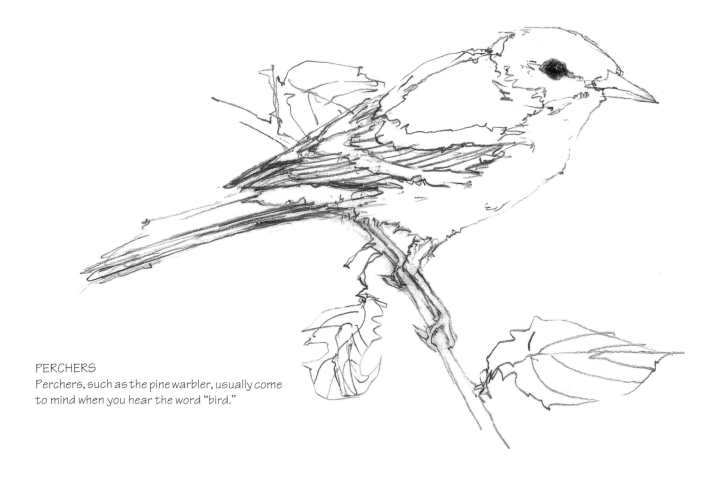

PERCHERS
Perchers, such as the pine warbler, usually come to mind when you hear the word "bird."

DIVERS

The belted kingfisher's body is more compact and less round than the duck's, allowing him to make fast dives.

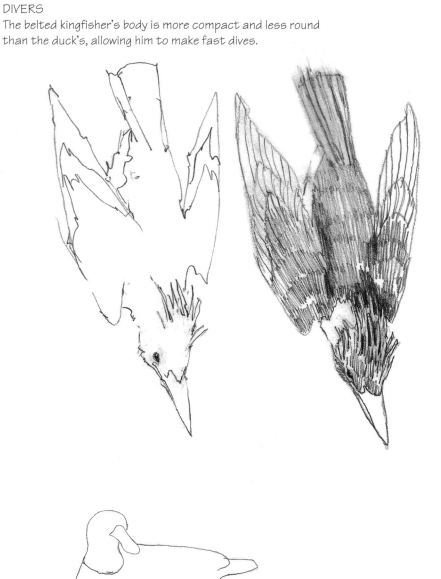

WADERS

Waders like this flamingo need long legs to keep their bodies above the water. A long neck allows him to dip his beak into the water from such a height.

SWIMMERS

Many swimmers have short legs and wide, paddle-like feet. This mallard's body is compact. As he feeds, he bobs in and out of the water much like a cork on a fishing line.

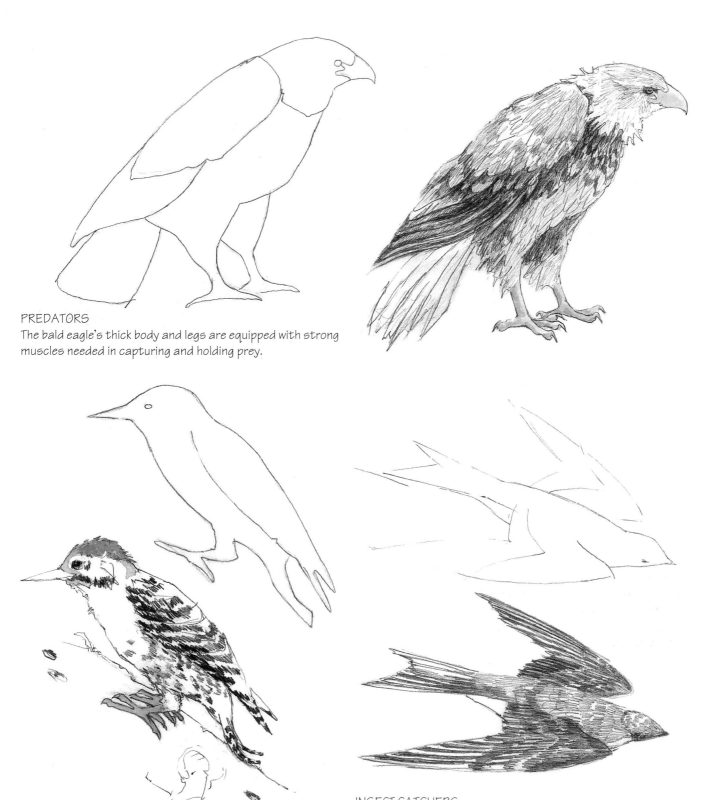

PREDATORS
The bald eagle's thick body and legs are equipped with strong muscles needed in capturing and holding prey.

TREE TRUNK CLINGERS
Strong toes and a thick, pointed beak enable the red-bellied woodpecker to bore holes while clinging to the side of a tree. His compact body gets additional support from bracing his short tail against the trunk.

INSECT CATCHERS
This chimney swift is shaped for bursts of speed, from the sharp V-shape of his wings to the V of his tail. The V is repeated in the tip of the wing.

Familiar Position and Silhouette

Certain positions are so strongly associated with particular birds that they become quick recognition aids, even from a distance. A bird's stance is an integral part of his shape. A hunched-down bird who looks almost neckless may be easily identified as an owl. One sitting with his head below his shoulders is usually a vulture. (Remember your mother telling you not to slouch?) Any unique feature in a bird's outline helps you recognize him. The line drawings here describe certain birds by using a combination of the basic structure of the bird with the way he sits and stands. Pay attention to the *outline*, or *silhouette*, surrounding the details.

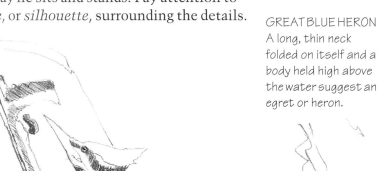

GREAT BLUE HERON
A long, thin neck folded on itself and a body held high above the water suggest an egret or heron.

PILEATED WOODPECKER
A woodpecker is seen more often clinging to a tree trunk rather than perched on a branch.

WHITE-BREASTED NUTHATCH
Nuthatches like tree trunks, too, but are usually seen head down.

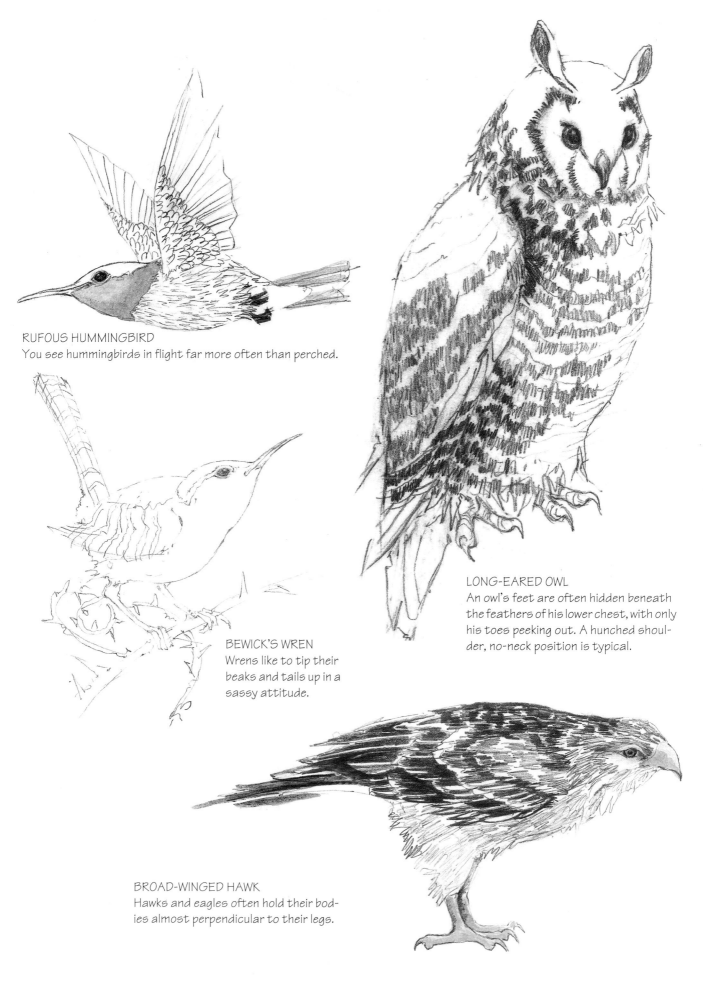

RUFOUS HUMMINGBIRD
You see hummingbirds in flight far more often than perched.

BEWICK'S WREN
Wrens like to tip their beaks and tails up in a sassy attitude.

LONG-EARED OWL
An owl's feet are often hidden beneath the feathers of his lower chest, with only his toes peeking out. A hunched shoulder, no-neck position is typical.

BROAD-WINGED HAWK
Hawks and eagles often hold their bodies almost perpendicular to their legs.

Beaks

Beaks come in a fascinating variety. They are large or small, thick or thin, straight or curved, blunt or pointed, plain or decorated, or any combination. This makes them especially useful in describing a bird.

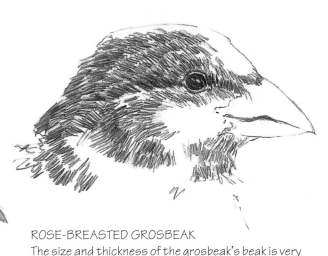

CARDINAL
The cardinal's bill is thick and large in proportion to his head. It's made for opening tough seed shells.

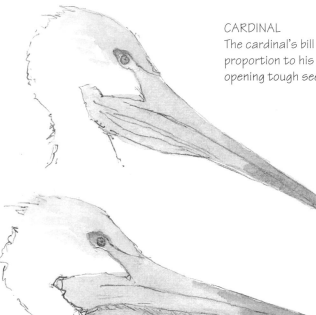

BROWN PELICAN
The pelican's silhouette is very much his own whether his famous beak is empty or full.

RED-BELLIED WOODPECKER
The red-bellied woodpecker's thick, pointed bill is his hole-chiseling tool. The beak grows as it's worn down.

ROSE-BREASTED GROSBEAK
The size and thickness of the grosbeak's beak is very pronounced, hence his name. He's a very strong seed-cracker.

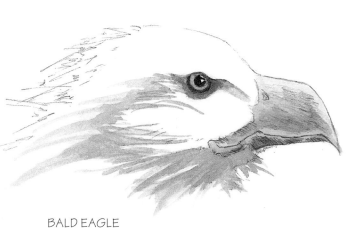

BALD EAGLE
The bald eagle's beak is a major part of his head, reflecting his role as a hunter. It ends in a sharp, pointed hook.

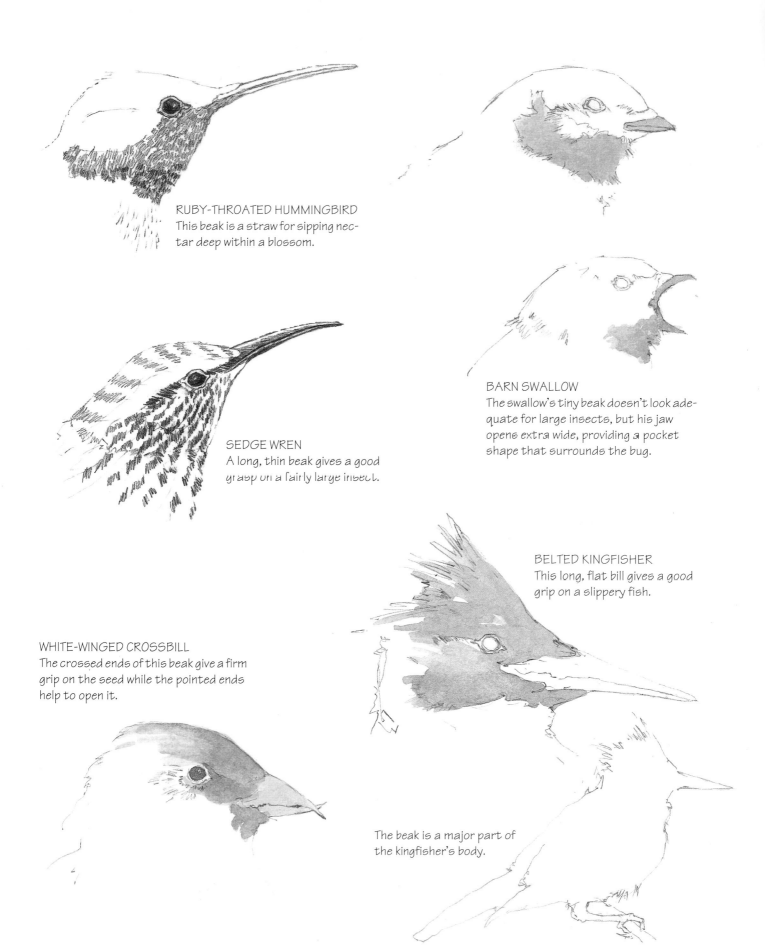

RUBY-THROATED HUMMINGBIRD
This beak is a straw for sipping nectar deep within a blossom.

SEDGE WREN
A long, thin beak gives a good grasp on a fairly large insect.

BARN SWALLOW
The swallow's tiny beak doesn't look adequate for large insects, but his jaw opens extra wide, providing a pocket shape that surrounds the bug.

BELTED KINGFISHER
This long, flat bill gives a good grip on a slippery fish.

WHITE-WINGED CROSSBILL
The crossed ends of this beak give a firm grip on the seed while the pointed ends help to open it.

The beak is a major part of the kingfisher's body.

Legs and Feet

Legs and feet strongly reflect lifestyle. Some legs are thin and delicate. Others are thick and powerful. Legs may be stilt-like or so short that they are almost invisible. Feet might have long delicate toes, large talons or may even be webbed. On some birds the back toe plays an important role, while on others it is almost nonexistent. Four toes are common, with one toe often pointed to the back. However, exceptions do exist (for example, the ostrich has two toes).

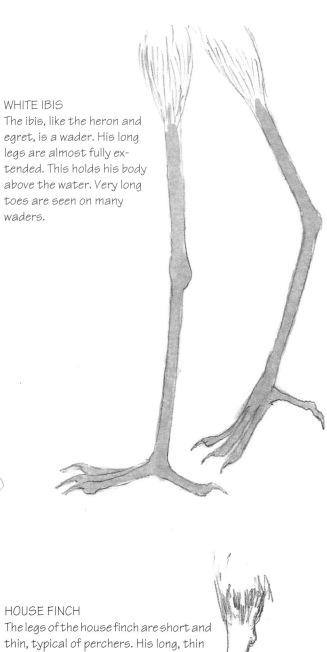

WHITE IBIS
The ibis, like the heron and egret, is a wader. His long legs are almost fully extended. This holds his body above the water. Very long toes are seen on many waders.

HOUSE FINCH
The legs of the house finch are short and thin, typical of perchers. His long, thin toes are designed for wrapping around a small branch.

DOWNY WOODPECKER
Long toes and talons give the downy woodpecker a firm grasp on a tree trunk. Two toes forward and two back strengthen his grip.

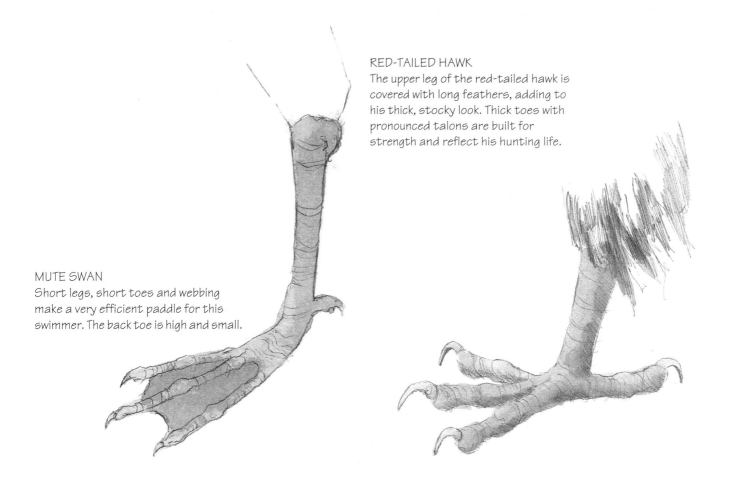

RED-TAILED HAWK
The upper leg of the red-tailed hawk is covered with long feathers, adding to his thick, stocky look. Thick toes with pronounced talons are built for strength and reflect his hunting life.

MUTE SWAN
Short legs, short toes and webbing make a very efficient paddle for this swimmer. The back toe is high and small.

Out on a Limb
Placing a percher on a limb can be difficult, especially since it is hard to get a close look at just what the foot is doing. On a broad surface the bird opens his foot so it rests on top of the perch. But how does he stay upright on a small branch or wire?

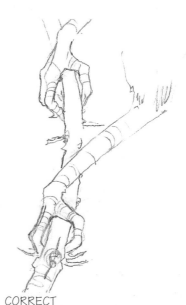

INCORRECT
A bird's foot is not constructed to allow him to squeeze down to tightly enclose a tiny limb.

CORRECT
On a small branch, the foot rests on the top of the branch and the toes bend at the joints. The rear toe locks in place. There is a space between the toes and the limb.

Eyes

There aren't the same simple generalizations to be made about eyes as there are for body shapes, beaks and feet. The similarities and differences in birds' eyes don't fall into neat or obvious groups. If we're looking at only the eye, without seeing the proportion of the eye to the head, the color of the eye or the markings around the eye, it can be hard to distinguish a sparrow's eye from that of a duck or woodpecker.

As you look at different aspects of birds' eyes—shape, proportion, markings and color—you find that changes occur as much from bird to bird as they do from group to group.

Shape of Eyes

You can simplify the eye to a basic oval shape that will serve you well for most purposes. There are a few obvious exceptions, such as owls. Their eyes are also slightly oval but can appear rounded, due in part to the markings around the eyes. Barn owls have a much rounder appearance to their eyes than horned owls whose eyes are partially covered by a ridge above them. In owls, skulls are shaped differently from those of most other birds, resulting in frontal positioning and closeness of the eyes. This contributes to the large, staring look we associate with owls. Like other birds, owls' eyes look very different if the lids are partially closed.

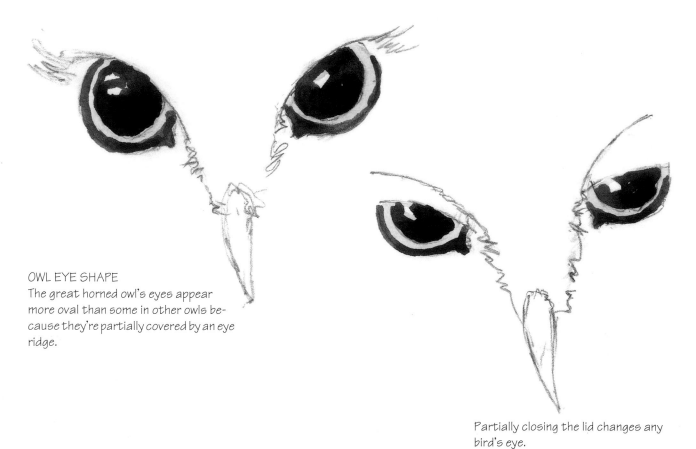

OWL EYE SHAPE
The great horned owl's eyes appear more oval than some in other owls because they're partially covered by an eye ridge.

Partially closing the lid changes any bird's eye.

Proportion of Eye to Head

Proportion is a good place to look for differences, but again it is hard to make generalizations. You need to look at individual birds. Some perchers (such as hummingbirds) have large eyes compared to their head size, but so do many predators (hawks, for example). And, of course, the proportion of eye to head stands out in owls.

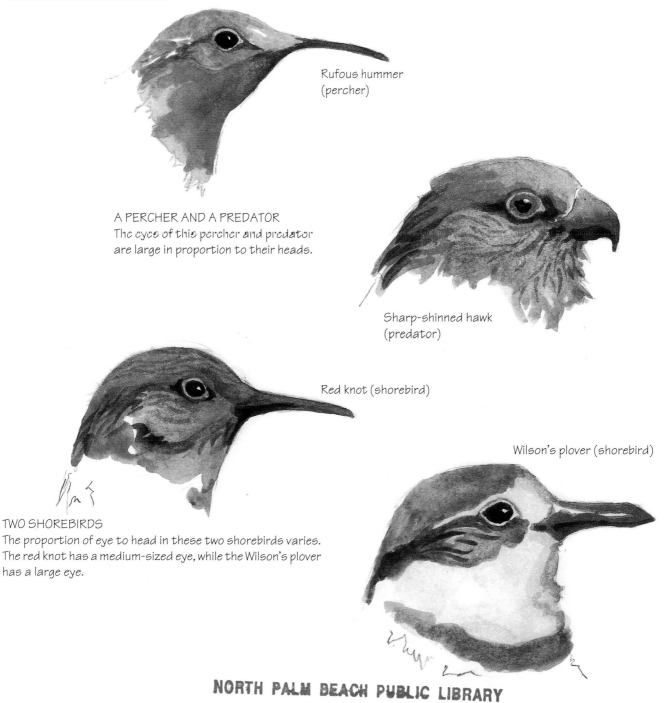

Rufous hummer (percher)

A PERCHER AND A PREDATOR
The eyes of this percher and predator are large in proportion to their heads.

Sharp-shinned hawk (predator)

Red knot (shorebird)

Wilson's plover (shorebird)

TWO SHOREBIRDS
The proportion of eye to head in these two shorebirds varies. The red knot has a medium-sized eye, while the Wilson's plover has a large eye.

More on Eyes

Markings Around the Eye

Some predators, such as the bald eagle, have a pronounced ridge above the eye when viewed from the front. Others like the American kestrel have a less pronounced ridge. This ridge can become more or less noticeable depending on the markings around the eye.

It's usually the *markings* around the eye that account for the different look from face to face, and these markings vary greatly even within each species, so much so that bird watchers find them extremely useful in making specific identifications. In each case, especially where you need a totally accurate eye, refer to a reliable source. Bird-watchers' guidebooks are great!

EYE RIDGES

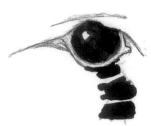

The bald eagle has a pronounced ridge above his eyes.

The American kestrel's eye ridge is less prominent.

EYE MARKINGS—VARIATIONS IN FIVE SPARROWS

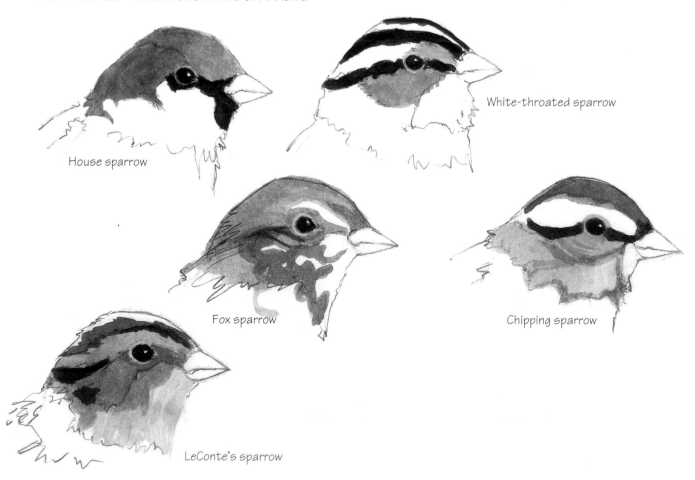

House sparrow

White-throated sparrow

Fox sparrow

Chipping sparrow

LeConte's sparrow

Color of the Eye

Many predators have brown eyes, but some, such as the bald eagle, have yellow eyes. The golden eagle and even an immature bald eagle have brown eyes, however. A few birds from each group from waterbirds to perchers have pink eyes.

Position of the Eye

Like other eye features, placement varies greatly. Again, the owl is an example of the extreme in eye placement. However, as we did with body shape, we can use perchers as models. Perchers' eyes, when viewed in profile, are usually a little above and forward of the center of the head. When you see the bird face-on, the eyes become very thin and tip inwards slightly at the top.

Don't Despair!

Even though there's so much variety that it's difficult to make many generalizations, most of the birds you'll paint won't be close enough for the eye to be a major concern, so keep eyes simple and undaunting wherever possible. The simple oval eye shown in the eye color examples will serve most of your needs. When the eyes are very small, getting the proportion accurate matters more than other factors. Where accuracy in shape, proportion, markings and color are important, use a reference source.

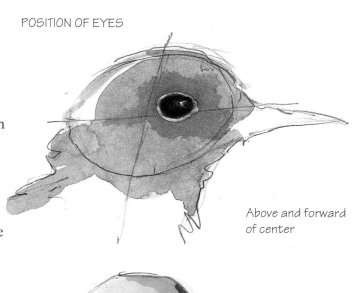

Above and forward of center

Elongated oval
Tipped slightly inward at top

COLOR
Eye color varies within each group.

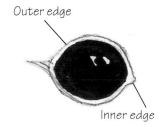

Outer edge

Inner edge

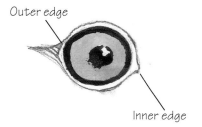

Outer edge

Inner edge

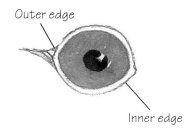

Outer edge

Inner edge

Brown Eyes	Yellow Eyes	Pink Eyes	
Swimmers	Ruddy duck	Tufted duck	Wood duck
Predators	Golden eagle	Bald eagle	Cooper's hawk
Perchers	Vermilion flycatcher	Brown thrasher	Red-eyed vireo

Wings

When wings are not in use, the bird folds them tightly against his body for maximum comfort and movability. Three joints allow a wing to fold and open quickly and efficiently. It's helpful to think of the joints in a human arm—shoulder, elbow and wrist—a bird's "finger" bones of the wing support the large feathers at the tip of the wing.

FOLDED WING

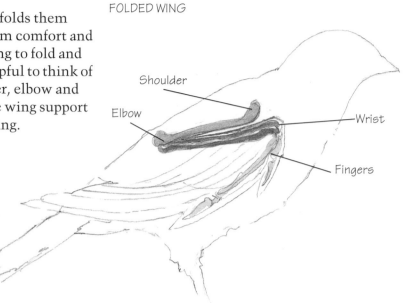

Shoulder

Elbow

Wrist

Fingers

PARTIALLY OPEN WING

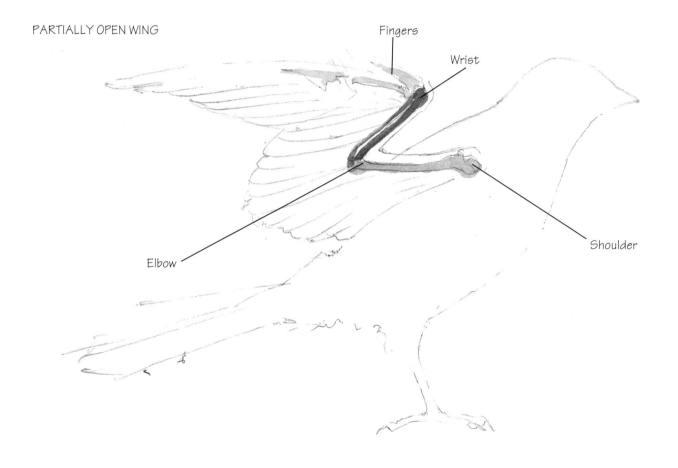

Fingers

Wrist

Shoulder

Elbow

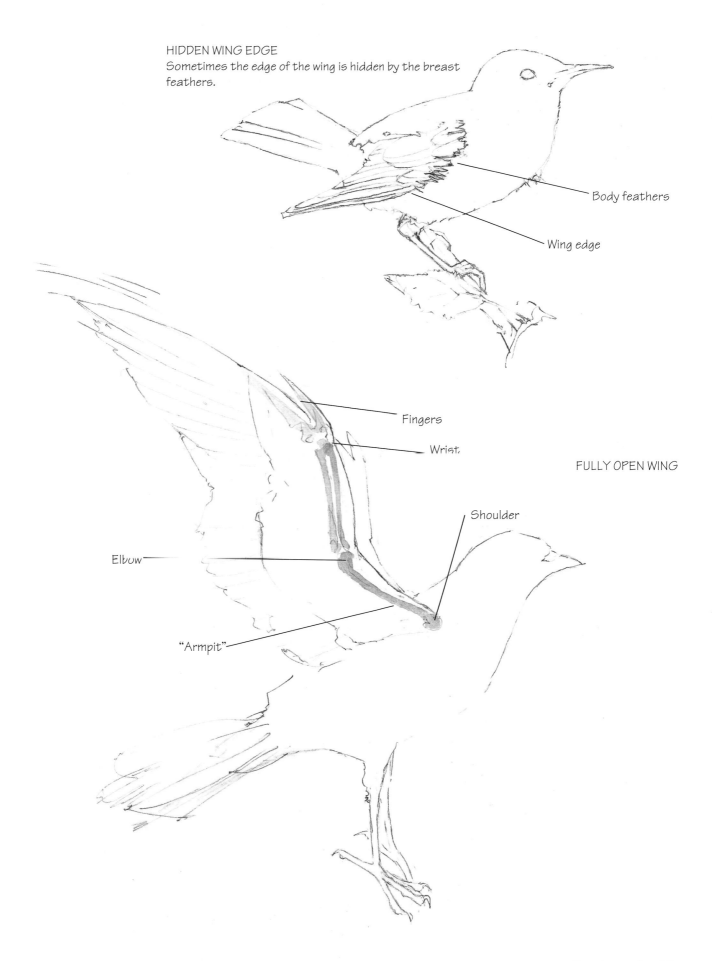

HIDDEN WING EDGE
Sometimes the edge of the wing is hidden by the breast feathers.

Body feathers

Wing edge

Fingers

Wrist

FULLY OPEN WING

Shoulder

Elbow

"Armpit"

Feathers

Feathers are unique to birds. They give them protection, aid in flight and add beautiful colors and patterns. The colors of feathers vary not only from bird to bird, but from feather to feather on the same bird. And a single feather may have several colors forming an intricate pattern. Body feathers are shorter, softer and more rounded than wing feathers. Wing and tail feathers are larger and more pointed.

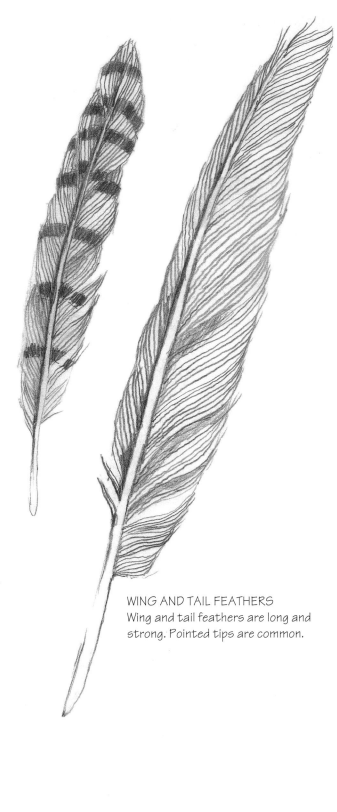

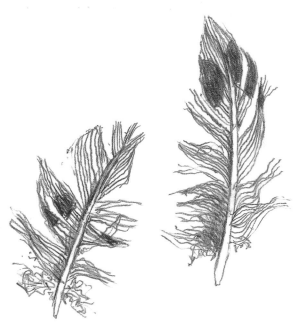

BODY FEATHERS
Body feathers are short and soft. The tips are often round or modified points, while the base is soft and fuzzy.

WING AND TAIL FEATHERS
Wing and tail feathers are long and strong. Pointed tips are common.

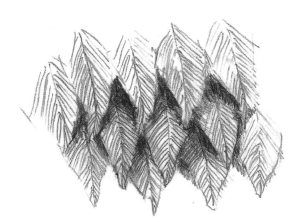

Feathers overlap like tiles on a roof.

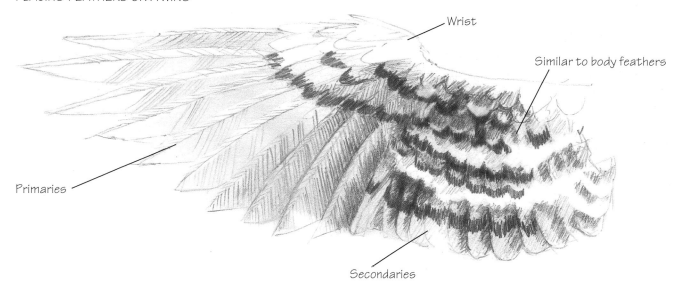

Wrist

Similar to body feathers

Primaries

Secondaries

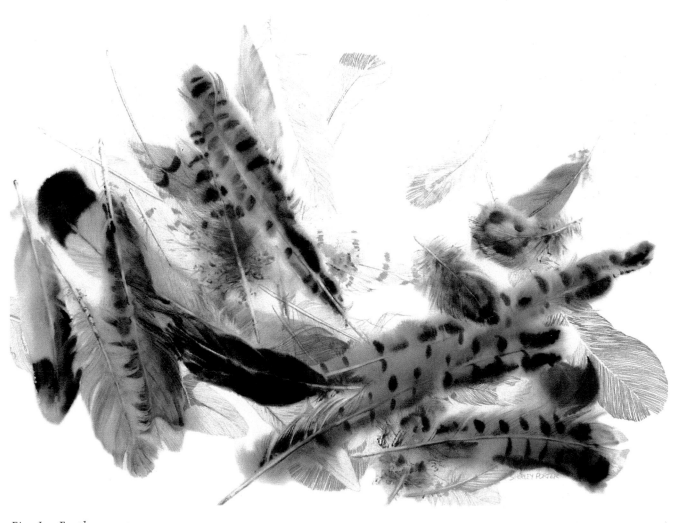

Five Jay Feathers
52″×32″ (132cm×81cm)

Looking for Similarities and Differences

Capturing the differences between a heron and a chickadee is simple because their differences are so pronounced. Showing the differences between basically similar birds, such as a chickadee and a titmouse, is a bigger challenge. Look first for the *similarities* to find the basic shape of the bird. Then look for the *differences* to identify a specific bird.

In nature, the size of a bird can be important in making an identification, especially from a distance. In a drawing or painting, though, it is often hard to tell a bird's size. You can show it against objects of a well-known size, perching a blue jay on a bucket, for example, to provide a frame of reference. If the bird, however, is among rocks, or swim-ming, or in loosely rendered foliage, you can't rely on size to help describe him. Again, *shape* and *detail* prove the most reliable tools for a successful rendering of the bird.

In the examples here, the three birds in each group are drawn approximately the same size even though in reality their sizes differ greatly. This helps focus on shape and detail for identification rather than on size. The three birds in each group have strong similarities, but look closely at the differences within each group, too. These differences will help you clearly define the bird you are drawing.

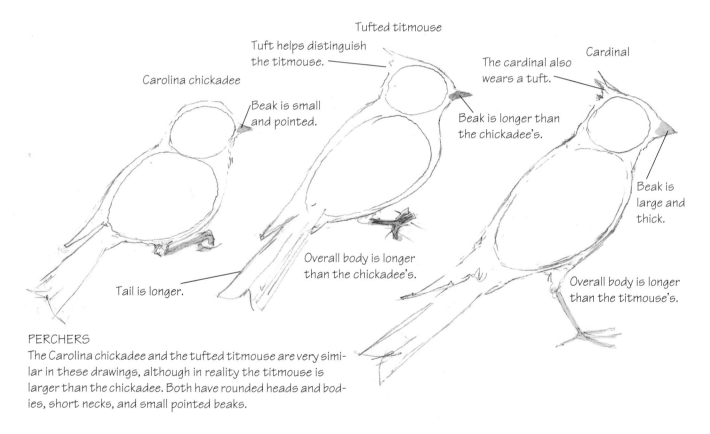

Tufted titmouse

Tuft helps distinguish the titmouse.

Carolina chickadee

Cardinal

The cardinal also wears a tuft.

Beak is small and pointed.

Beak is longer than the chickadee's.

Beak is large and thick.

Tail is longer.

Overall body is longer than the chickadee's.

Overall body is longer than the titmouse's.

PERCHERS
The Carolina chickadee and the tufted titmouse are very similar in these drawings, although in reality the titmouse is larger than the chickadee. Both have rounded heads and bodies, short necks, and small pointed beaks.

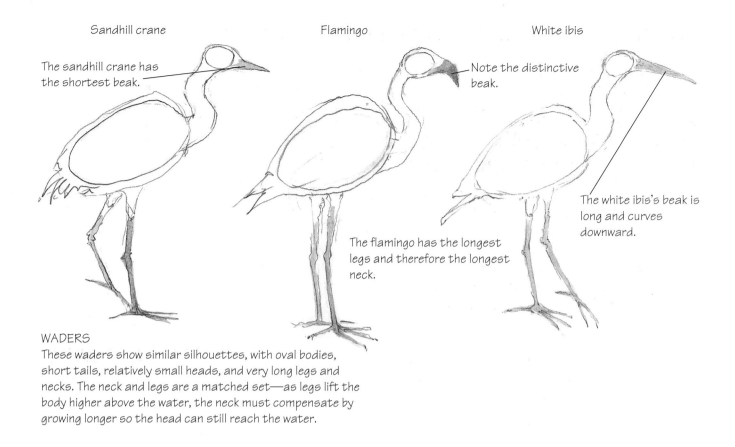

Sandhill crane

The sandhill crane has the shortest beak.

Flamingo

Note the distinctive beak.

The flamingo has the longest legs and therefore the longest neck.

White ibis

The white ibis's beak is long and curves downward.

WADERS

These waders show similar silhouettes, with oval bodies, short tails, relatively small heads, and very long legs and necks. The neck and legs are a matched set—as legs lift the body higher above the water, the neck must compensate by growing longer so the head can still reach the water.

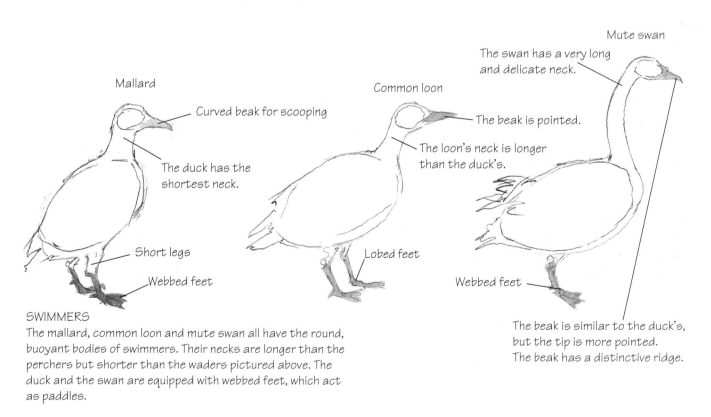

Mallard

Curved beak for scooping

The duck has the shortest neck.

Short legs

Webbed feet

Common loon

The beak is pointed.

The loon's neck is longer than the duck's.

Lobed feet

Mute swan

The swan has a very long and delicate neck.

Webbed feet

The beak is similar to the duck's, but the tip is more pointed. The beak has a distinctive ridge.

SWIMMERS

The mallard, common loon and mute swan all have the round, buoyant bodies of swimmers. Their necks are longer than the perchers but shorter than the waders pictured above. The duck and the swan are equipped with webbed feet, which act as paddles.

Drawing With Ovals

This turkey is begun by roughing in ovals to place the body and head. Notice how the ovals are placed to accommodate this specific pose. Look for positions that help describe the bird or tell a story about him. This turkey had no problem letting me know he didn't appreciate my company. He simply turned his back.

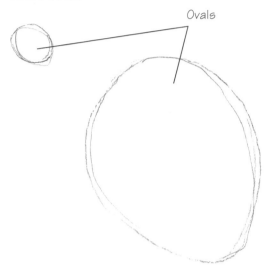

Step 1: Draw Ovals
Draw a large oval for the body and a small oval for the head. Place them to accommodate the pose.

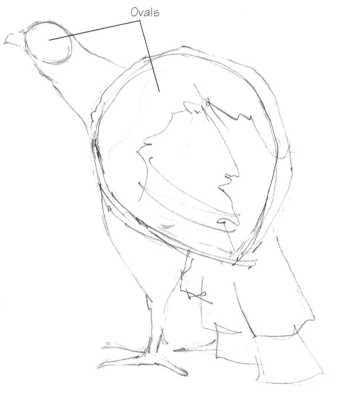

Step 2: Connect Parts
Join the head and body with a long neck. Add a leg and foot and the beak. Locate the edges of the wings and tail feathers.

Step 3: Define Feathers
Draw feather edges in the back and tail. Add the wattle.

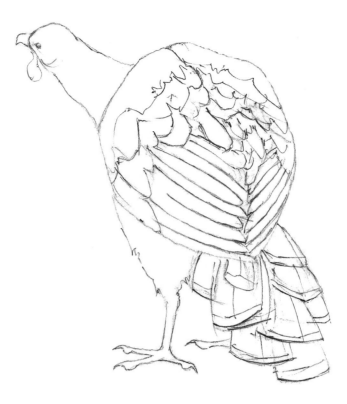

Step 4: Add Final Details
Add details with a range of values from dark to light. I changed the position of the foot.

Use a light pressure for fine lines.

A pattern in the feathers adds interest.

Combine light and dark areas for more interest.

Use a heavy pressure for darker areas.

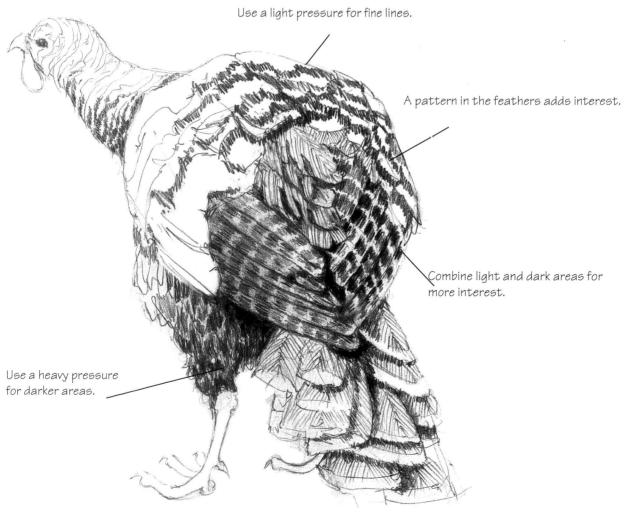

Drawing With an Outline

Begin drawing this osprey with a simple outline to define shape and pose. I wanted to show the simple dignity of this osprey, so I pictured him standing, looking toward me. That way I could emphasize the importance his talons and beak play in his life-style, by placing them up front.

Step 1: Draw an Outline
Outline the bird's general shape and position.

Step 2: Define Body Parts
Locate the eyes and beak. Outline the wings and neck. Begin shaping the toes.

Step 3: Add Feathers

Add cheek and breast feathers. Draw individual wing and tail feathers. Add the branch.

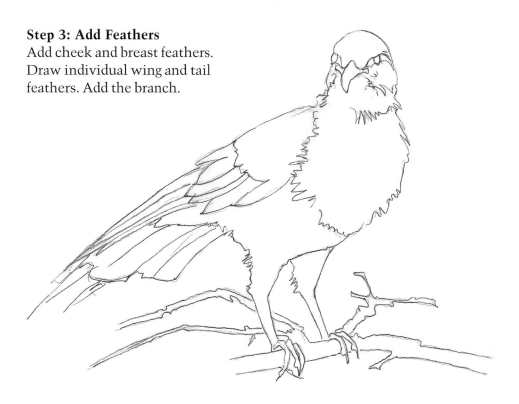

Step 4: Add Details

Add chest spots and tail pattern. Make the wing and back darker than the chest. Model the body by using a lighter value on the left side than on the right side.

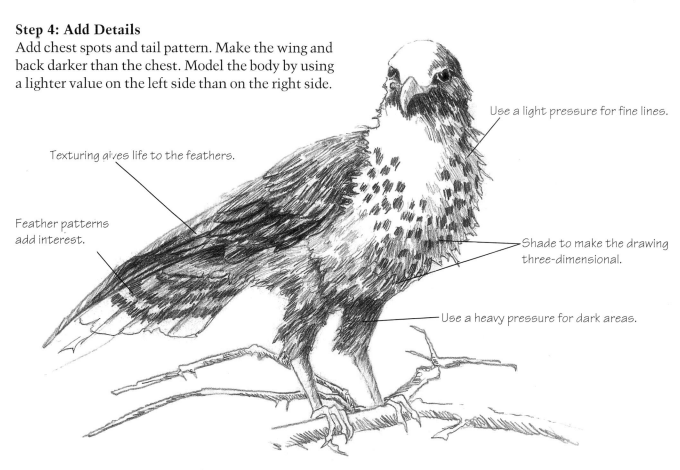

Texturing gives life to the feathers.

Feather patterns add interest.

Use a light pressure for fine lines.

Shade to make the drawing three-dimensional.

Use a heavy pressure for dark areas.

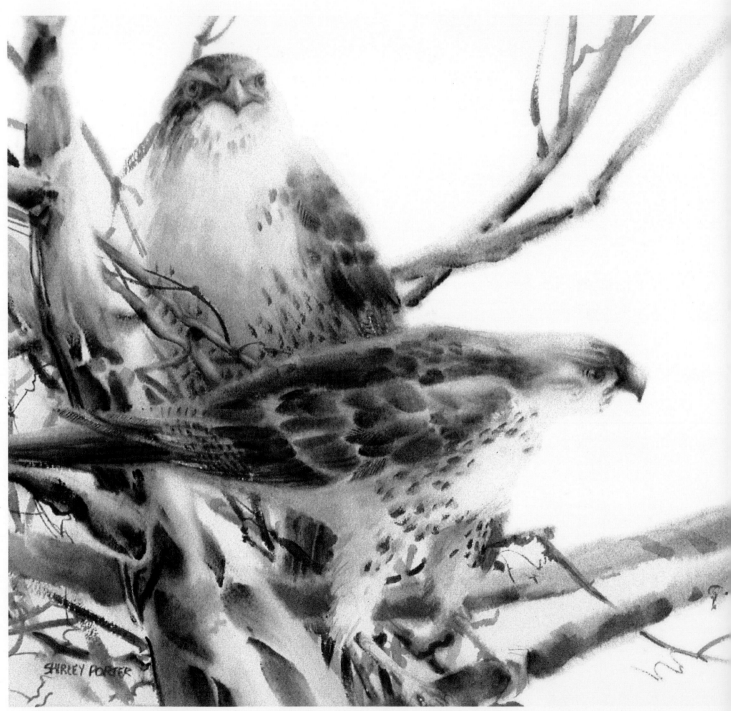

Two Red Tails
22″×15″ (56cm×38cm)

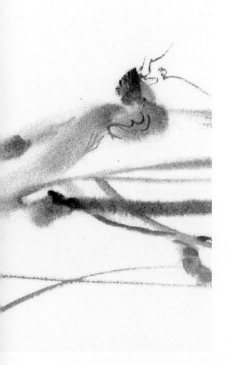

2

PAINTING BIRDS

Now that you've studied the basic shapes of some bird groups, along with their important features, you'll want to add color and feather patterns to your bird pictures. We'll use a simple selection of colors for each painting, creating a large variety of colors and values simply by altering the proportion of one color to another and the amount of water we add to each mixture. It's especially helpful to limit the number of colors you use for any one painting when you're beginning, because you don't get lost so easily. We'll also explore the different effects of working on wet or dry paper, and we'll work with modeling the birds to make them look three-dimensional.

Painting Supplies

Brushes

I learned to paint using synthetic brushes and recommend them for several reasons. First, they are considerably cheaper than natural-hair brushes. Also, from time to time you are bound to succumb to a little scrubbing with a brush not intended for that purpose, damaging the shape and point of the brush. A synthetic brush is more forgiving of this transgression than a fine hair brush. I also like knowing I'm happily painting birds without putting other critters in harm's way. Years ago when synthetics first came on the market, they were stiff, had poor points or quickly lost their points and didn't hold much paint. They've come a long way. Newer versions are very pliant, hold paint well and can have good points.

When choosing a brush, always wet it thoroughly first. The art store should provide a cup of water in the brush section. If there's no sign of one, ask. A good supply store knows why you want it. (In order to save myself time and frustration, I carry my own water supply in an empty film can.) Soak the brush until the sizing (the stuff they use to make the bristles hard and bring them to a very fine, and very temporary, point) is washed out and the

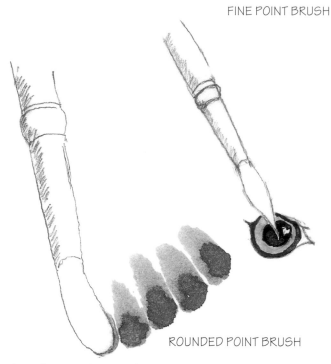

ROUNDED POINT BRUSH

bristles are thoroughly wet. Give the brush a good shake with a hard flick of the wrist. Has the point re-formed? Is it an extremely fine or a somewhat broad point? There are uses for both. What matters is whether or not the point suits your needs. Repeat the wetting and shaking process several times. Test the brush's resilience by painting the palm or back of your hand with the water. You can see and feel whether or not the brush meets the surface with a "springiness," or just sort of lies there. Resilience allows a brush to quickly respond to the subtleties of your hand movements. Wetting the brush tells you how much paint it will hold, too. Check the ferrule (the metal band around the top of the bristles) for tightness. There should be no wiggle in the motion of the brushstroke.

Rounds. Look for the finest points on the smallest brushes, the ones you'll use for eyes, toes and feather detailing. A sharp point gives you control in small, delicate areas.

For larger body areas and big background areas, a wide point or even no point at all works well. Here you need a stroke that begins and ends broadly and can easily be blended into surrounding colors. This is a good brush to use for the rounded tips of feathers.

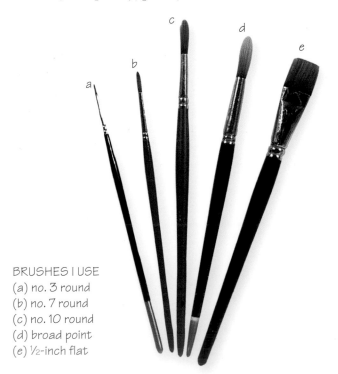

BRUSHES I USE
(a) no. 3 round
(b) no. 7 round
(c) no. 10 round
(d) broad point
(e) ½-inch flat

Flats. Large flat brushes work well for big areas and for washing in the first layer of areas that will be overlaid with more color and detail. The edge can be used to paint sharp straight lines and to lift sharp lines and highlights in a still damp area.

Scrubbers. Sometimes, instead of adding paint, you need to remove it, and remove more than just lifting of the color allows. A "scrubber" is a great tool for ridding a painting of an unsatisfactory area. An inexpensive bristle brush designed for painting oils and acrylics makes a good scrubber. Cut the bristles very short and use it to scrub painted areas you want to change. Several sizes are handy, allowing you to scrub delicate to very large areas.

Always wet the area to be scrubbed before starting, as wet watercolor can be removed more easily. Then dry the area completely before doing more scrubbing or drawing or painting in that area. Dry paper is stronger than wet paper and less likely to be damaged. Scrubbing removes the sizing and some of the paper. This causes the scrubbed area to look different from the rest when it is painted because it will absorb more paint. The more you scrub, the more paper and sizing you remove, so proceed with care. I have even occasionally scrubbed a hole in my paper!

I seldom use more than three brushes on a painting, using the largest one for most of the piece and the smallest one only for details. When I paint a large piece I often use a flat for everything except the smallest details. Most of the paintings we'll do in this book will be 9" × 12" (23cm × 30cm), so you won't need any really large brushes. I suggest that you cut several sheets of paper to size so they'll be ready when you want to paint.

Paper and Boards

Watercolor paper varies in quality. Papers that are acid free and have a high rag content are far more durable than those that do not. Papers may be single sheets, sheets glued at the edges to form a "block," or a sheet mounted on a backing—usually a thick cardboard—to stiffen it and help it resist buckling when the paper is wet. These backed papers are known as watercolor board or illustration board.

Weight of Paper. Watercolor paper may be thin, 90 lb. (190gsm), or very thick, 300 lb. (638gsm). Lighter weight papers (90 lb.) buckle easily with the addition of only a little moisture. Heavy paper (300 lb.) can absorb a lot of water before it buckles. The *smaller* and *drier* you work, the *lighter* the paper you can use. The larger or wetter a painting will be, the *more support* it requires to prevent buckling. Buckling can be eliminated or lessened in several ways: (1) using less water; (2) using a heavyweight paper; (3) using a premounted paper such as watercolor board or illustration board; or (4) stretching the watercolor paper before or after you paint.

Paper Surfaces. A smooth surface makes fine detailing easier, especially in a small painting. Rough surfaces have a deep texture with pronounced hills and valleys. Some mixed colors and pigments separate on rough surfaces, giving you beautiful effects that cannot be duplicated on a smooth surface.

These surfaces are categorized as hot pressed (very smooth), cold pressed (moderately textured), or rough (deeply textured). Each characteristic makes the paper work well for some techniques and not so well for others.

Palette

A plastic palette with a cover helps keep paints moist when they are not being used, but only for a short period of time. Dividers between the colors keep each color from running into those surrounding it. It is important that the mixing area be white, mimicking the color of the watercolor paper, so you can accurately judge the colors as you mix.

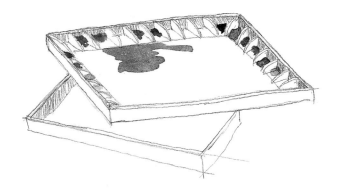

More Painting Supplies

Paint

Artist-quality paints contain more pigment than student-grade and therefore give richer color. Be careful to select colors with a good lightfast rating. *Fugitive colors* (easily fading) are often very pretty, but are only suitable for a piece not intended to last, a piece that is being done only for reproduction or as a study. Manufacturers use different notations to indicate color lightfast ratings.

For example, Winsor & Newton rates their watercolors with "AA" as the best lightfast rating and "C" as the lowest. You'll find the lightfast rating printed on the paint tube. Paints that come in a tube are nice to work with because they are already moist. This moistness is also easier on your brushes as you pick up the paint and mix colors than cake or pan paints would be.

Limiting Your Colors. Using a limited palette of colors allows you to become familiar with those colors. Limiting the number of colors also helps pull the completed painting together. In fact, it's one of the simplest things you can do to ensure your painting's unity.

Don't hesitate to add a color you need or one you just like. Just be careful not to use such a variety that your painting begins to look spotty. If your painting has a strong *basic* color theme, you can add quite a variety of color accents and still have a unified piece.

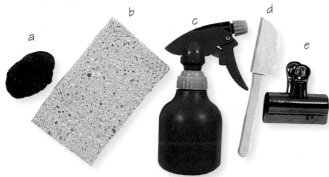

The following miscellaneous tools will come in handy when painting: (a) natural sponge; (b) synthetic sponge; (c) sprayer; (d) scraper; (e) metal clamp.

Miscellaneous Tools

Scrapers. Any object with a somewhat sharp edge can be used to scrape away still-damp pigment, creating light and dark areas. These same tools can be used for scoring (see "Transfer the Drawing," pages 48–49).

Sprayers. Sprayers allow you to spritz the painting without disturbing it as brushing on water would do. They are useful for keeping the paint on your palette wet, too.

Sponges. Sponges are used to dab on paint or lift it from still-damp areas, creating textures. As the softness and hardness and the shape and texture of the sponges vary, so will the texture you're creating on the painting. I use a sponge to wipe my brush on after I've rinsed out a color in preparation for picking up the next color.

Metal Clamps. Metal clamps hold the wet watercolor paper to the Masonite board as the paper dries, causing it to stretch flat. Buying enough clamps to completely encircle the paper's edge can be a little costly, but they will last throughout your painting career.

Masonite Boards (several sizes). A single paper sheet needs support, especially if it is large or has been soaked in water. A Masonite board cut 2" (5cm) larger than the watercolor paper in both dimensions works well. The extra dimension allows the board to accommodate the wet paper's expanded size.

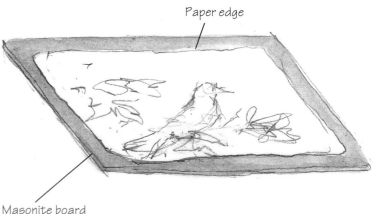

Paper edge

Masonite board

Permanent Blue: a basic, medium blue.

Phthalo Blue: a stain. Dark, rich and translucent. Good for mixing.

Winsor Red: medium red.

Alizarin Crimson: a stain. Deep and rich. Good for mixing.

Burnt Sienna: a warm, rusty brown.

New Gamboge: a clear pure yellow.

Raw Sienna: an earthy yellow.

Yellow Ochre: an earth color. Somewhat opaque. Well suited to nature subjects.

Burnt Umber: a dark reddish brown.

Hooker's Green: medium green that lends itself well to foliage.

Raw Umber: a yellowish brown.

Phthalo Green: a stain. Rich, dark and translucent. Good for mixing.

Sepia: a very dark brown. Opaque.

Painting Techniques and Tips

Modeling

You can model (make three-dimensional) a bird by varying the lightness and darkness of his color. Areas catching the most light are palest or brightest and those on undersides or away from the light are darkest, so the bird looks darker underneath and lighter on his head and back. If he is facing away from the light, the bird's back appears lighter than his chest, if they are the same color. His face and chest are brighter if he faces into the light. A simple method for modeling is to paint a lighter, or a darker, mix of the basic color into an area. These lighter and darker mixes of the basic color become highlights and shadows. Highlight by blotting or lifting damp color or by painting with a thinner mix of your color. Shade by applying a less liquid version of the color, by adding blue or gray to the color or by adding the color's complement (opposite on the color wheel).

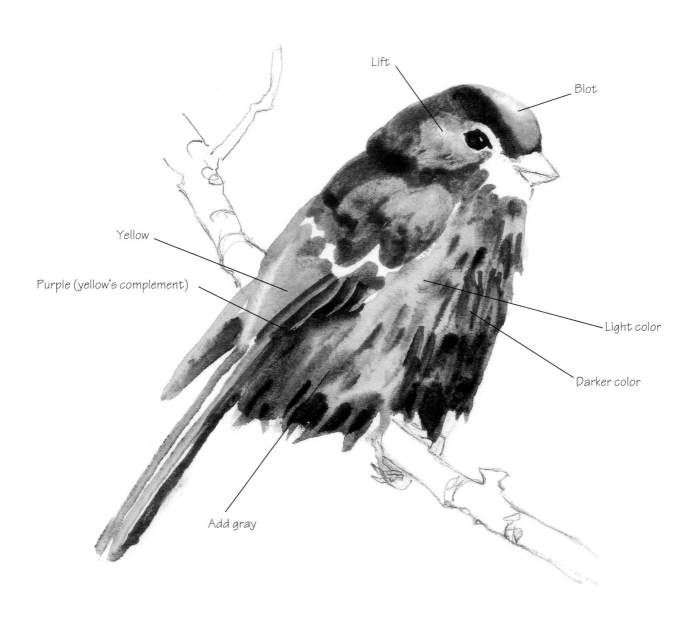

Lift

Blot

Yellow

Purple (yellow's complement)

Light color

Darker color

Add gray

Lifting Color

You can use a damp brush to lift (remove) pigment before it dries. This leaves a stain of color and gives a texture you can't get any other way. Lifting works well for defining feathers. Both the side and the sharper edge of a flat brush work well to lift detail.

Scoring

Scoring is scraping the paper with any tool, such as a pencil point or brush handle, to create a fine groove. This groove will absorb more color than the areas immediately surrounding it, making it darker. Scoring is great for creating fine line textures, such as feather detailing, especially in larger paintings. I seldom use it in small paintings because it makes too strong a line for the painting area.

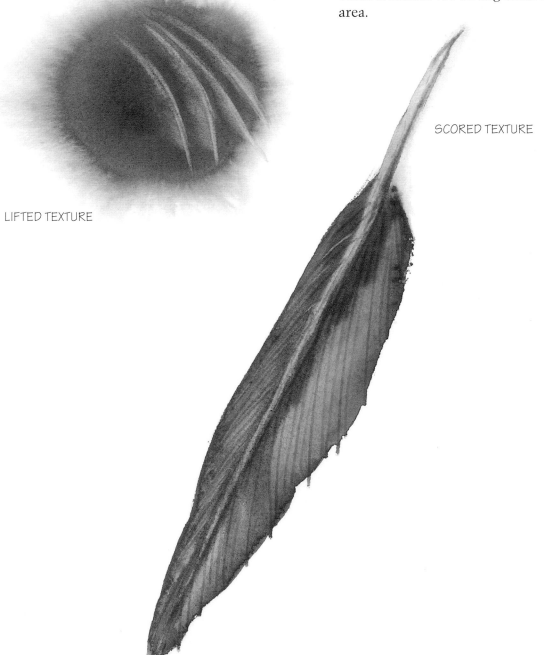

LIFTED TEXTURE

SCORED TEXTURE

More Painting Techniques

Painting Light to Dark

In watercolor it's generally best to wash in light areas first and add dark areas last because the dark colors will cover the light but not vice versa. Unsatisfactory light areas can be easily corrected. Dark ones cannot. A good strategy is to first underpaint dark areas with a light color. This establishes the placement and shape of what will later become a dark area. While it is in a light wash, you can still make major changes. When the final darker color is applied over the light wash, you can give it added sparkle by leaving bits of the light underpainting showing.

Painting Large to Small

For added control as you paint, define large areas first and add smaller details last. This is not a hard rule, though. If a large area is dark and a small area within it is light, then you must save the small light area. You can either paint around the area to be saved or mask it with frisket, a thick gummy substance similar to rubber cement. Frisket is designed to be painted over an area that you want unchanged by following layers of color. I prefer painting around the area because it gives a softer edge. If the small area is a light color, I often paint it first and then paint the darker color up to its edge. Watercolor demands that you plan each stage of the painting. You can't do a lot of backing up!

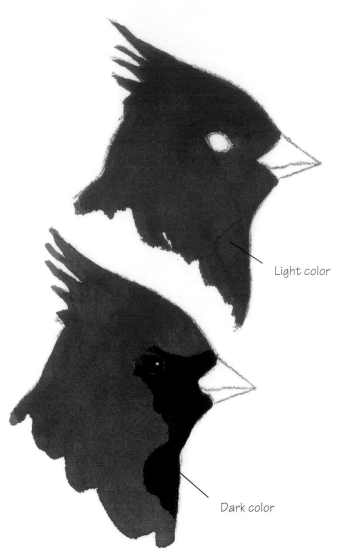

Light color

Dark color

PAINTING LIGHT TO DARK
You can paint a lighter color over what will become a darker area. I've painted around the eye to save a highlight.

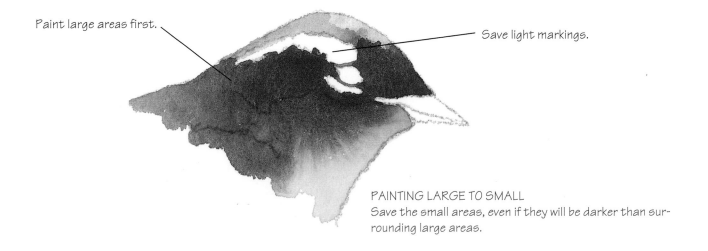

Paint large areas first.

Save light markings.

PAINTING LARGE TO SMALL
Save the small areas, even if they will be darker than surrounding large areas.

Establishing Attitude

Although I usually wash in large areas first and then begin to put in the detail, I do make exceptions to this order. I sometimes paint the eye, and maybe the beak, first. This is because these two features are very descriptive. Just an eye—with its highlight—on the white page gives the suggestion of life. The beak, like the mouth in a human portrait, establishes attitude. When the bird occupies a major part of the overall design, painting in the eye and the beak in the early stages helps establish the mood of the painting.

Softening an Edge

A painted brushstroke made on dry paper will dry with a very defined edge. You can soften that edge by painting it with a brush of clear water before it dries. Then, gradually brush away from the painted area. The color will become more diluted as it moves away from the painted area, resulting in a soft edge. You can soften edges that have already dried using the same method, but they won't soften nearly as much.

Establishing a Direction

Totally different effects result from emphasizing selected aspects of your painting. You can make some decisions as you work, but most need to be made at the beginning so that each addition moves the painting toward your goal.

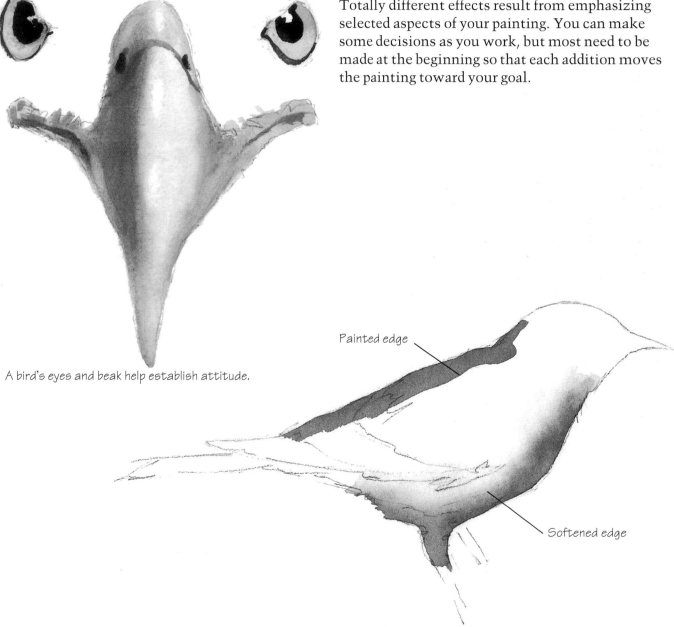

A bird's eyes and beak help establish attitude.

Painted edge

Softened edge

Working From a Drawing

The drawing for your painting can be detailed, even including a color study, or it can be very simple. And, of course, you can paint without making any drawing at all. It depends on your personal working preference.

Simple Drawing

When you work loosely and want to define many components of the painting as you work, you can start with a very simple drawing. Sometimes this is a basic drawing of the bird and the background in outline. Or it may be just a few rough circles, ovals and lines to represent the major shapes of the painting. This can be done on a separate piece of paper or directly on the painting surface.

Detailed Drawing

For a realistic painting, making a detailed drawing helps avoid mistakes that can spoil the painting, especially when you're using watercolor. This transparent medium forgives a surprising range of goof-ups, but there are some that are so major that you have to discard the painting and start over. Obviously, if you have planned carefully, this is less likely to happen, and a good drawing is an essential part of this planning. Sometimes this will mean a drawing that shows every feather. Other times, it might be a careful outline showing the bird's shape and pose and locating some major parts of the background. Usually the more lifelike I want the painting to be, the more detailed drawing I make.

Transfer the Drawing

A transfer paper has a coated side that acts like carbon paper when placed between the drawing and the watercolor paper. You can make a transfer paper by covering one side of a strong (but not thick) paper with graphite. Prepared transfer paper can be purchased at an art supply store.

SIMPLE DRAWING

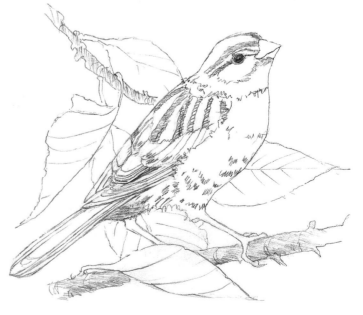

DETAILED DRAWING

Whether transferring or drawing directly on the watercolor paper, you need to put your drawing on the watercolor paper *while it is dry*. Drawing on a soft, wet surface or directly on the watercolor paper with heavy pressure can leave marks that will not cover or erase and can permanently score the paper. (I often use scoring to advantage, drawing and scraping purposely in a damp surface to create texture and detail.)

When you're ready to transfer, place a sheet of transfer paper shiny side down on your watercolor paper. Then place your drawing on top and trace over the drawing with a light touch. Check the transfer often as you work to be sure you're getting the darkness you want. It needs to be only dark enough that you do not lose your way as you paint.

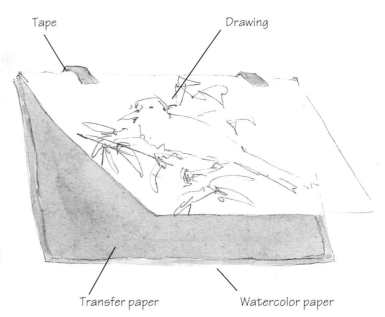

Tape

Drawing

Transfer paper

Watercolor paper

SCORED PAPER

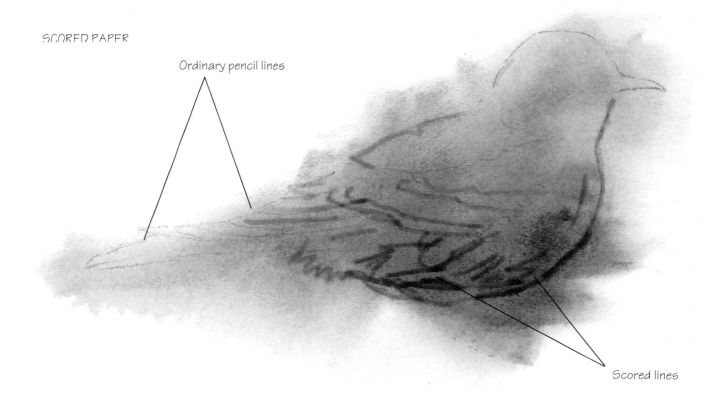

Ordinary pencil lines

Scored lines

Working on Dry or Wet Paper

Dry Paper

If you want defined edges and a lot of exacting detail, using dry paper or board works best. Colors painted onto a dry paper stay just where the brush puts them. Working dry is great for painting realistically and for painting fine detail such as eyes and toes. You have more control because you know exactly what will happen with each brushstroke.

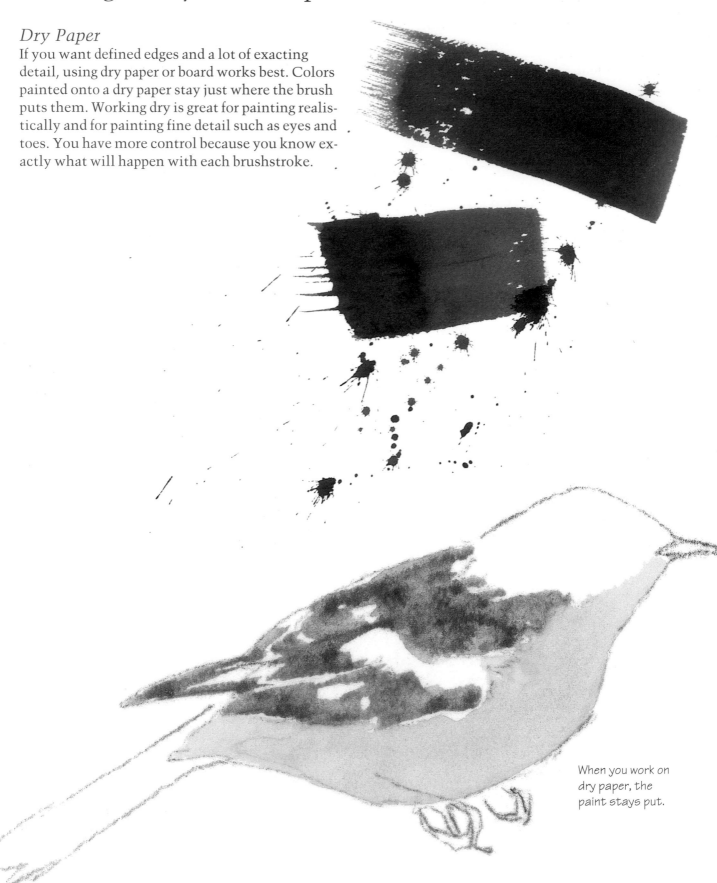

When you work on dry paper, the paint stays put.

Wet Paper

If your aim is for soft edges, loosely suggested areas, and colors blending freely from one to another, soaking the paper first makes these effects easier to achieve.

Working wet is ideal where you want subtle passages and edges, such as in feathers. When working wet-in-wet, don't paint all the way to the edge of a shape or the color will flow beyond it. Leave any fine detailing such as eyes and toes until last, when your paper is almost completely dry.

Soaking Your Paper

Fill a shallow, waterproof container (large enough for a sheet of watercolor paper) with just enough water to cover the paper. I use a homemade soaking tray made from plywood and plastic. If your soaking tray is large, be sure to include a drain for emptying dirty water. Otherwise you will have to carry the full tray to a sink and empty it without a major spill! A bathtub works well, too.

Immerse your paper and leave it until completely saturated. Remove the paper and place it on your Masonite board, tipping one corner down to let the excess water drain off the paper and you're ready to paint. The wetness of the paper will hold it against the board, and you can do a lot of painting before you need to clamp the paper to the board. (The clamps would be in your way if you put them around the painting earlier.) When the edges of the paper start to dry and separate from the board, secure them to the board with metal clamps. The clamps should be shoulder-to-shoulder with no gaps between them. As the paper dries and shrinks to its original size, it will stretch tightly across the board.

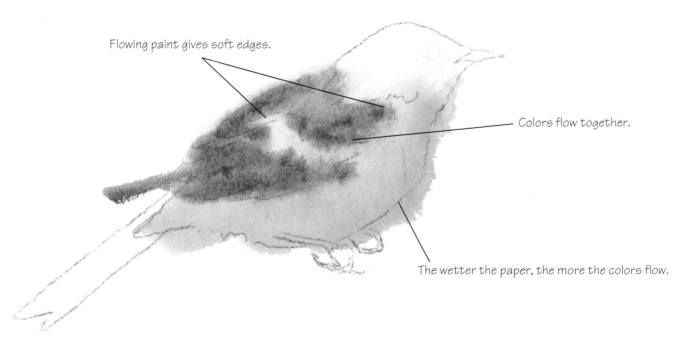

Flowing paint gives soft edges.

Colors flow together.

The wetter the paper, the more the colors flow.

Exercise One: Common Flicker
Painting on Pre-Wet Paper

Even when working on dry paper you can get a soft look by brushing clear water into an area before painting. The edges where colors meet within this area will be soft, as contrasted with the sharp edge formed where the wet area meets the dry.

Complete Drawing
Draw a common flicker in pencil.

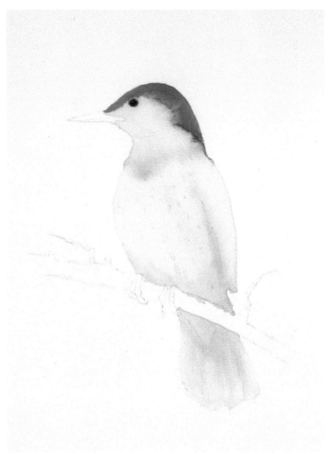

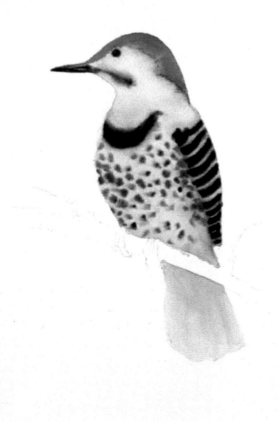

Step 1: Underpainting

Use a no. 7 round to apply water over the body of the bird. On the damp surface, paint the top of the head with a mixture of Winsor Red and Hooker's Green. Wash in the face and neck with Winsor Red and Yellow Ochre mixed. Underpaint the body with a grayed mix of Permanent Blue, Yellow Ochre and Winsor Red. Use this same mix to darken the lower edge of the body and outline the wing. Let dry.

Use a no. 0 brush to paint the eye with a black mix of Winsor Red and Phthalo Green.

Step 2: Paint the Markings

Wash Yellow Ochre over the entire body with a no. 7 round brush. While the area is still damp, paint the brown collar and spots with Sepia. Paint in the soft black bars on the wing with a mixture of Winsor Red and Phthalo Green. Paint this same mix on the beak and into the face.

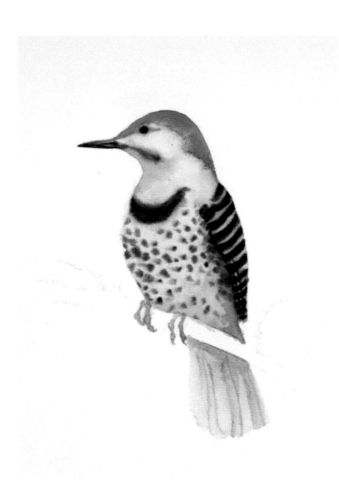

Paper
Cold-pressed Arches
140 lb. (300gsm)

Palette
Yellow Ochre
New Gamboge
Winsor Red
Hooker's Green
Phthalo Green
Permanent Blue
Sepia

Brushes
no. 7, no. 3, no. 0 round

Step 3: Add Detail
Use a no. 3 round to define the cheek and tail with the gray mix. Then use a no. 0 round to paint the toes with a thin wash of the mixed black. Mix Winsor Red and Yellow Ochre for the eyepatch.

Step 4: Model the Body
Use a no. 3 round to model the head with your Winsor Red/Yellow Ochre mix and the body with a Winsor Red/Permanent Blue mix. Use your thinned black to deepen the patch on the cheek and give dimension to the toes.

Common Flicker
12″×9″ (30cm×23cm)

Exercise Two: Cardinal (Male)
Painting on Soaked Paper

A soaked paper gives you soft edges throughout
your painting. As the paper dries, the additions you
make become more defined.

**Complete
Drawing**
Draw a cardinal
in pencil.

Paper
Cold-pressed Arches
140 lb. (300gsm)

Palette
New Gamboge
Winsor Red
Hooker's Green
Raw Sienna
Raw Umber
Yellow Ochre

Brushes
no. 7, no. 3, no. 0 round

Step 1: Underpaint Large Areas
Soak and drain your paper, and place it on your Ma-
sonite board. Use a no. 7 round to wash a Winsor Red/
Raw Sienna mix in the body and berries. Vary the de-
gree of Red and Sienna in certain areas to give dimen-
sion. Mix New Gamboge and Hooker's Green for the
leaves.

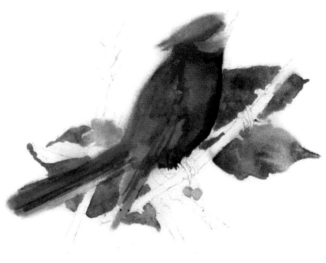

Step 2: Model the Body
Mix Winsor Red with Hooker's Green to form a
grayed version of the body color and use a no. 7 round
to model the bird's underside. Add Raw Sienna to the
head and back to highlight them.

Step 3: Define Feathers

Use the red-green mix and a no. 3 round to further model the underside and to define feathers in the face and wings. More Raw Sienna suggests sunlight on the back.

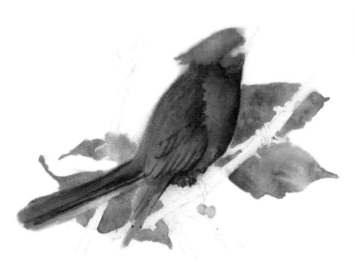

Step 4: Add Details

Now your paper is almost dry. Use a strong Winsor Red/Hooker's Green mix for the black pattern in the face and eye, using a no. 0 round for the eye and a no. 3 round for everything else. Make a thin wash of the black mix as the gray color of the legs. Detail the leaves with the New Gamboge/Hooker's Green mix. Detail the branches with Raw Umber, adding additional layers of color as needed to model. Mix Winsor Red and Yellow Ochre for the beak. Then, with a small scrubber, gently lift a highlight in the beak, head, back and tail. Clamp the paper all the way around to a Masonite board so your painting dries flat.

Cardinal
12" × 9" (30cm × 23cm)

Exercise Three: Green Heron
Painting on Dry Paper

Painting on a paper that is totally dry from start to finish gives clearly defined edges throughout the piece.

**Complete
Drawing**
Draw a green heron in pencil.

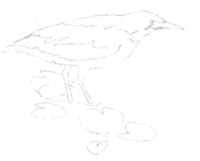

Paper
Cold-pressed Arches
140 lb. (300gsm)

Palette
New Gamboge
Winsor Red
Hooker's Green
Permanent Blue
Burnt Umber
Yellow Ochre

Brushes
no. 7, no. 3 round

Step 1: Paint Large Areas
Use a no. 7 round to paint the chest pattern with Burnt Umber. Be careful to save the white areas, which represent white chest feathers and feather edges. Mix Hooker's Green and Burnt Umber to paint the back and wings. Blot the upper edge of the back with a paper towel to create a highlight. Use this same green on the lily pads, blotting or darkening in areas to give the illusion of highlight and shadow.

Step 2: Continue to Build Form
Paint the head and wing tips using a no. 3 round with a gray mix of Permanent Blue, Winsor Red and New Gamboge. Add a highlight to the head by blotting with a paper towel. Paint a thinned gray (more water) on the chest, throat and lower body.

Step 3: Add Details to the Wings
Using a damp brush, soften the white areas in the wings with a no. 3 round by brushing color from their edges toward their center. Define wing feathers with the mix of Hooker's Green and Burnt Umber.

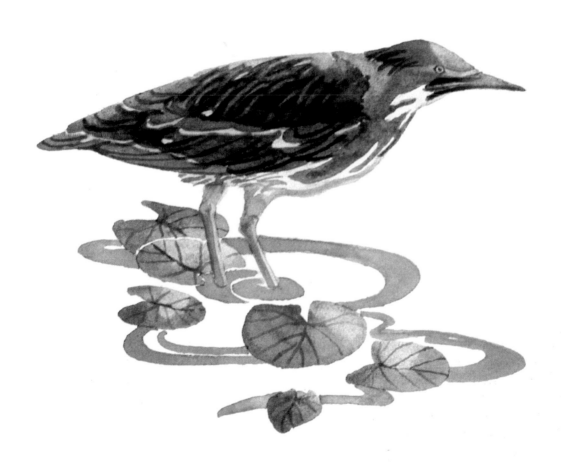

Green Heron
12" × 9"
(30cm × 23cm)

Step 4: Add More Details
Paint New Gamboge on the face, beak and eye. Define the beak, eye, lower body feathers and back of the head with the gray mix of Permanent Blue, Winsor Red and New Gamboge. Paint in Yellow Ochre on the legs with a no. 3 round, modeling to create roundness with additional layers of color. Detail the lily pads with a darker version of your green mix and add water and paint with a swirling pattern of Permanent Blue.

Exercise Four: Ring-Billed Gull
Painting a Loose Background

Working on thoroughly wet paper is a good way to get the bird to become part of the background. The colors flow freely from one to the other and edges are lost into the background. As the painting dries, you can add defining sharp edges where needed. The colors of this immature gull reflect those in the sand around it.

Complete Drawing
Draw a gull in pencil.

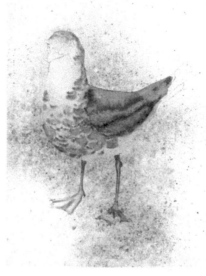

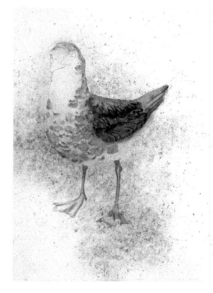

Step 1: Suggest Sand
Soak and drain your paper, and place it on your Masonite board. Using a ½-inch flat brush, wash the gull and surrounding area with Raw Umber. With the no. 7 brush, spatter more Raw Umber and Burnt Umber to suggest sand. If you've never done spattering before, practice first on a discarded sheet of paper. Lift color with clear water and a brush from the light face and chest area of the gull.

Step 2: Underpaint Large Areas
Using a broad-pointed no. 7 brush, suggest feathers on the breast, head and neck with Raw Umber and a mix of Burnt Umber and Permanent Blue. You want a fairly dry paint mix for this texturing. Press the rounded tip of the color-filled brush against the paper to form a pattern of crescent-shaped marks representing feather tips. Then, underpaint the wings and back with these same colors. Mix Raw Umber and Winsor Red and paint the legs using less color in areas of highlight to create form.

Step 3: Add Details
Now the paper is fairly dry, and you are ready to begin adding detail. Suggest some individual wing and tail feathers using a no. 3 round with a brown-gray mixed from Permanent Blue, Winsor Red and Raw Umber. Use a blue-gray mix of Burnt Umber and Permanent Blue to define feathers on the back and lower wing areas.

Paper
Cold-pressed Arches
140 lb. (300gsm)

Palette
Winsor Red
Permanent Blue
Raw Umber
Burnt Umber
Yellow Ochre
Sepia

Brushes
½-inch flat
no. 7, no. 3, no. 0 round
no. 7 broad-point
Scrubber

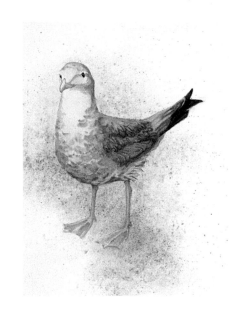

Step 4: Refine Details and Form

Using a no. 3 round, model the body with the blue-gray mix of step 3: Add shadows to define the face, round out the lower belly, and detail the lower body feathers. Use a no. 0 round to add the eyes with Sepia. Paint the beak with a Yellow Ochre/Winsor Red mix using a no. 3 brush. Develop feet and legs, adding more Raw Umber/Winsor Red mix to give form.

Step 5: Scrub and Change

This is a good example of making adjustments as you paint. The color and value of the legs in step 4 are too close to the background color, so they do not show up well. Wet the legs and the background area close to the legs, and gently lift the leg color with a scrubber. Then, dry the paper thoroughly and darken the legs with a Yellow Ochre and the blue-gray mix from step 3. Further define the face and body with additional layers of color as needed. Clamp your paper all the way around to your Masonite board so your painting dries flat.

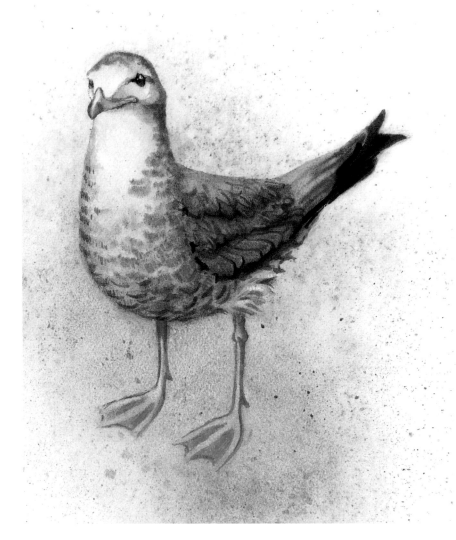

Ring-Billed Gull
12″×9″ (30cm×23cm)

Exercise Five: Baltimore Oriole
Underpainting With Yellow

An effective and easy way to give a light-filled warmth to your painting is to first underpaint an area with yellow. When the following layers of paint are added, the yellow shows just enough to move the colors toward a warmer feel.

Paper
Cold-pressed Arches
140 lb. (300gsm)

Palette
New Gamboge
Yellow Ochre
Alizarin Crimson
Winsor Blue
Permanent Blue
Winsor Green

Brushes
no. 7, no. 3, no. 0 round

Complete Drawing
Draw an oriole in pencil.

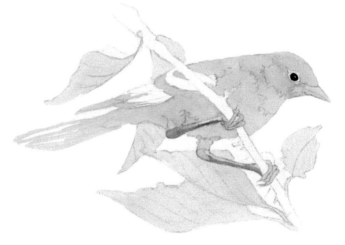

Step 1: Underpaint Large Areas
Using a no. 7 round, underpaint the entire body and the leaves with New Gamboge to give a warm, lively glow. The black of the eye and the gray of the beak and legs are a mixture of Winsor Blue, Alizarin Crimson and New Gamboge. These transparent colors make a lively black. Leave areas of white on the legs and wings as highlights. Let dry.

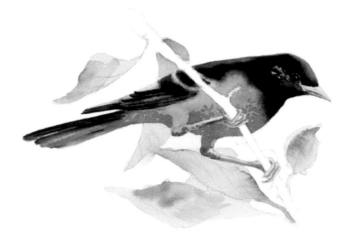

Step 2: Add Color and Model

Using a no. 7 round gently wash a layer of clear water over the bird and leaves. Then, paint the underside of the bird with orange mixed from Alizarin Crimson and New Gamboge. Paint in the head, back and tail with a darker version of the black mix from step 1.

Use a no. 3 round to model the breast with Permanent Blue and the legs and beak with a thinned black. Let some underpainting show on the cheek for texture. Darken the circle surrounding the eye using a no. 0 round and a thin wash of your black mixture. Create highlighting by letting the yellow show on the head, back and sides. Add some orange in the leaves for color balance.

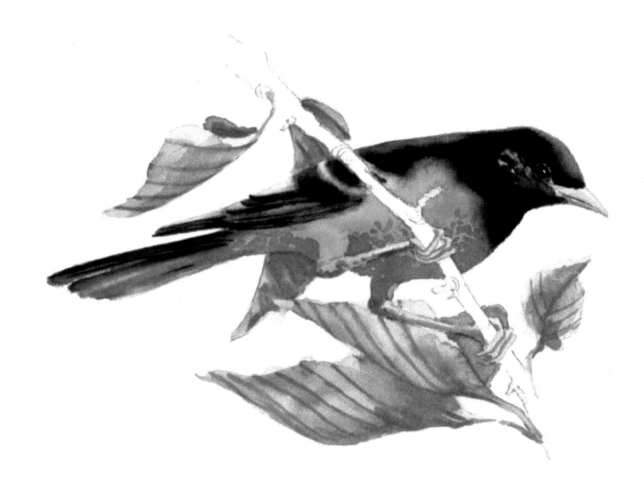

Step 3: Complete the Leaves

Add a mix of Winsor Green and Yellow Ochre to the leaves for texture and a variety of color. I've chosen to leave the branch in pencil for drama.

Baltimore Oriole
12″×9″ (30cm×23cm)

Exercise Six: White-Throated Sparrow
Painting Feather Patterns

Many sparrows look deceptively simple to paint. What seems at first glance to be a plain brown bird is often adorned with a detailed pattern. This makes it more beautiful but also more difficult to paint.

Complete Drawing
Draw a sparrow in pencil.

Step 1: Underpaint the Body
Use your no. 3 round to paint the eye with Burnt Umber, saving a highlight. Paint the yellow eye spot with New Gamboge. With your no. 7 round, wet the body area and underpaint it with a gray mixture of New Gamboge, Permanent Blue and Winsor Red. Paint around the white wing details to save them. Don't worry if some of the gray bleeds into the white area. This will soften it. The beak is a darker version of the same gray. Paint the legs with Yellow Ochre.

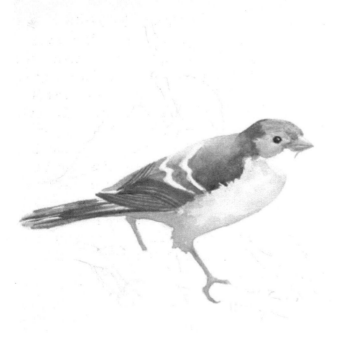

Step 2: Paint the Back and Tail
Wet the back and tail areas with clear water, and use a no. 7 round to paint them with Burnt Umber. Lighten the umber as you move from wing to beak to begin modeling. Save the white areas. Delineate wing tips and tail with additional Burnt Umber details. Model face, legs and underbelly with the gray mixture from step 1.

Paper
Cold-pressed Arches
140 lb. (300gsm)

Palette
Alizarin Crimson
New Gamboge
Yellow Ochre
Winsor Red
Permanent Blue
Hooker's Green
Burnt Umber

Brushes
no. 7, no. 3 round

Step 3: Paint the Pattern
Paint the black wing, back and tail pattern using a no. 3 round with a dark version of the gray mix from step 1. Blot the damp color to produce a highlight. Add light applications of the gray to further model the face and underbelly. Paint on gray to model the legs.

Step 4: Paint the Details
Sharpen the feather delineation. Model the belly with gray and the legs with Yellow Ochre and gray. Soften the white wing patterns with a wash of Burnt Umber and a no. 3 round. Mix New Gamboge and Hooker's Green to paint the leaves and their veins. Use the same color on the two branches and the small berry stems. Mix a little Alizarin Crimson with Permanent Blue to paint the berries. Leave a highlight in each one.

White-Throated Sparrow
12″×9″ (30cm×23cm)

Exercise Seven: Barn Owl
Painting Intricate Feather Patterns

This is an exercise in painting intricate feather patterns. Like the pattern in the sparrow, one layer will cover another. Here, though, we'll paint more small, fine areas than were in the sparrow.

Complete Drawing
Pencil in the drawing of this barn owl.

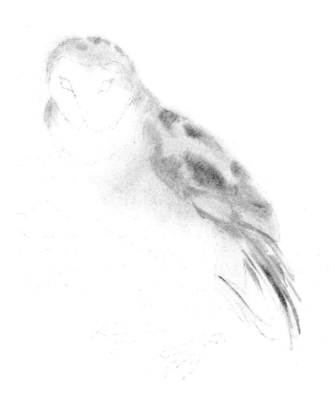

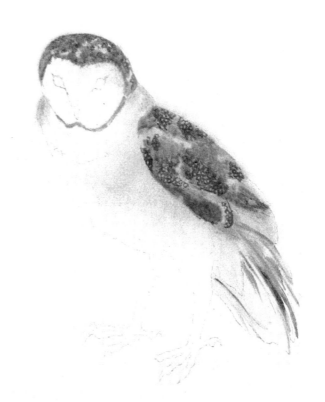

Step 1: Underpaint the Body
Soak and drain your paper, and place it on your Masonite board. Brush Raw Umber lightly over the back, tail and head with a no. 7 round. Mix a gray of Raw Umber, Permanent Blue and Alizarin Crimson and add patterned areas to the back, tail and head, leaving small spots of the original umber color showing as you go. Brush strokes of Burnt Sienna into the tail feathers.

Step 2: Add Darker Colors
Paint the medium-brown passage of the head and wing with mixed Burnt Sienna and Permanent Blue using a no. 3 round. Darken some areas of Raw Umber on the head and back with additional layers of color. Darken the gray areas with your gray mix from step 1, letting some of the lighter underpainting show through as you go, to create a speckled texture.

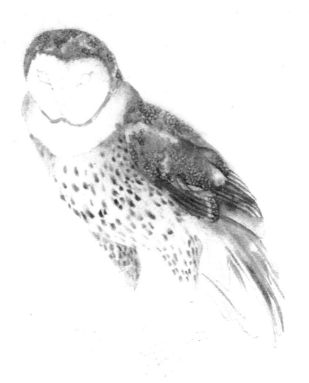

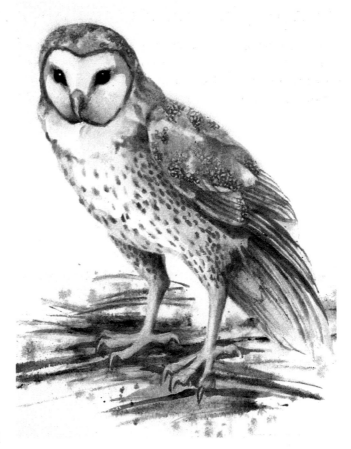

Step 3: Define Feathers and Spots

Delineate feathers using the same gray mix of step 1 and the brown mix of step 2. Mix Burnt Sienna and Permanent Blue for the chest and leg speckles. Paint the speckles by pressing the side of the no. 3 round against the paper.

Step 4: Create Form

Now your paper is almost dry so you can add the finishing details. Paint the eyes with Burnt Sienna mixed with Permanent Blue. Use a no. 3 round to model the face, body, tail and legs with Raw Umber and your gray mixture of step 1, giving shape to the belly and face, and shadow to the legs and underside. Use some Raw Umber and Burnt Umber in the straw. Clamp the paper all the way around to your Masonite board so your painting dries flat.

Barn Owl
12" × 9"
(30cm × 23cm)

Paper
Cold-pressed Arches
140 lb. (300gsm)

Palette
Burnt Sienna
Burnt Umber
Permanent Blue
Raw Umber
Alizarin Crimson

Brushes
no. 7, no. 3 round

Exercise Eight: Ruby-Throated Hummingbird
Painting an Open Wing

Wings are unique to birds and an important part of painting birds. Few animals can change their appearance as quickly or dramatically as a bird can, simply by opening its wings. A partially or fully open wing creates an entirely new silhouette.

Paper
Cold-pressed Arches
140 lb. (300gsm)

Palette
New Gamboge
Alizarin Crimson
Hooker's Green
Permanent Blue
Raw Umber

Brushes
no. 7, no.3, no. 0 round

Complete Drawing
Draw a hummingbird in pencil.

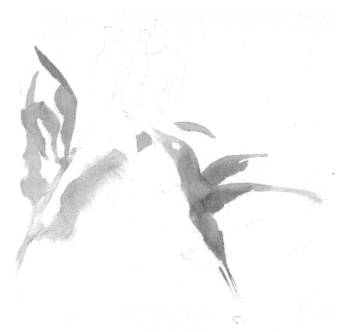

Step 1: Underpaint the Large Shapes
Soak and drain your paper, and place it on your Masonite board. Mix a gray with Alizarin Crimson, New Gamboge and Hooker's Green to paint the head, wings and back of the bird with a no. 7 round. Paint the leaves with mixed New Gamboge and Hooker's Green.

Step 2: Paint the Red Areas
Paint the throat of the bird and the flower with Alizarin Crimson using a no. 7 round. Apply additional Alizarin Crimson to deepen the speckles of the bird's throat and to give the flower color variation.

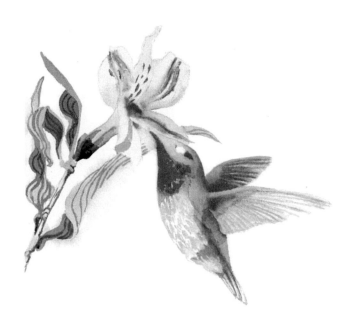

Step 3: Detail Feathers and Model the Body

With a darker mix of the gray in step 1, paint individual belly and wing feathers with this gray using a no. 3 round. Model the upper body and wings with this same gray. Darken the undersides of the leaves with a green mix of Alizarin Crimson, Hooker's Green and New Gamboge. Then use this green mix to delineate wing feathers, add details to the flower, and add texture to the leaves.

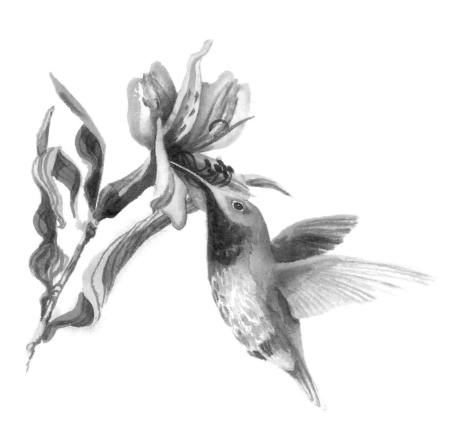

Step 4: Paint the Small Details

Use your gray mix from step 3 to darken the distant wing and the body with a no. 3 round. Using your no. 0 brush, paint the eyes, toes and beak with a dark solution of this same mix. With your no. 3 brush add Alizarin Crimson and New Gamboge to darken the flower petals. Add Raw Umber to the leaves for color variety. Clamp the paper all the way around to your Masonite board so your painting dries flat.

Ruby-Throated Hummingbird
12″ × 9″ (30cm × 23cm)

Exercise Nine: Red-Tailed Hawk
Painting a Frontal View

Showing a bird looking directly at you makes a dramatic painting. It also involves special challenges. You can no longer rely heavily on the silhouette to identify the bird. You can't see the length and much of the shape of its beak clearly. You see the tip and the corners. The eyes become oval and lean slightly inward at the top and the cheeks become prominent.

Paper
Cold-pressed Arches
140 lb. (300gsm)

Palette
Permanent Blue
Raw Sienna
Burnt Sienna
Burnt Umber

Brushes
no. 7, no. 3, no. 0 round

Complete Drawing
Draw a hawk in pencil.

Step 1: Underpaint the Large Areas
Soak and drain your paper, and place it on your Masonite board. Use Raw Sienna to underpaint the head, back, legs and branches with a no. 7 round.

Step 2: Underpaint the Patterns
Mix a gray of Permanent Blue and Burnt Sienna and paint the chest using a no. 7 round. Indicate soft feathers on the chest and legs. Use these same colors to model the branch.

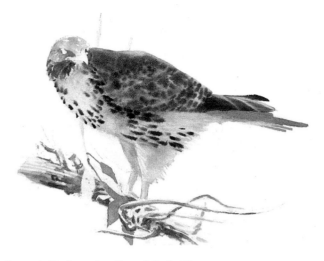

Step 3: More Underpainting
Paint in Burnt Sienna for the pattern on the back, head and tail with a no. 3 round. This will enliven the final darker feather pattern. Paint leaves and branches with this same color.

Step 4: Paint the Speckled Chest
Now the paper is just barely damp. Mix Burnt Sienna and Permanent Blue to paint the darkest feather color and model the face with a no. 3 round. Use a darker version of this color for the speckled chest and tail and to give form to the branch.

Step 5: Paint Fine Detail
When the paper is quite dry, use a no. 3 round to add the sharp feather edges of the body, head and legs with a mix of Burnt Sienna and Permanent Blue. Paint the beak with Raw Sienna and add finishing details to the branch and leaves with the same gray mix from step 2. Use the no. 0 brush to paint the eye with Burnt Sienna mixed with Permanent Blue.

Use the no. 3 round to wash the branch and leaves with Raw Sienna. Add darker Raw Sienna (less dilute) to some of the leaves. Paint other leaves and some of the branch with Burnt Sienna. Mix Burnt Sienna and Permanent Blue to add dark modeling to the branch and fine detail to the branch and leaves. Clamp the paper all the way around to the Masonite board so your painting dries flat.

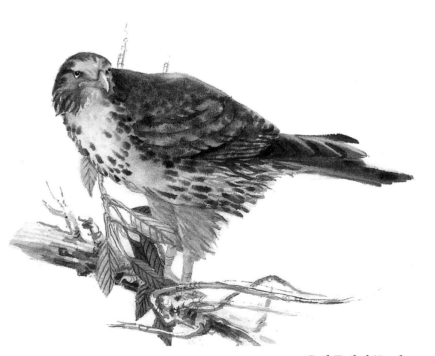

Red-Tailed Hawk
12″×9″ (30cm×23cm)

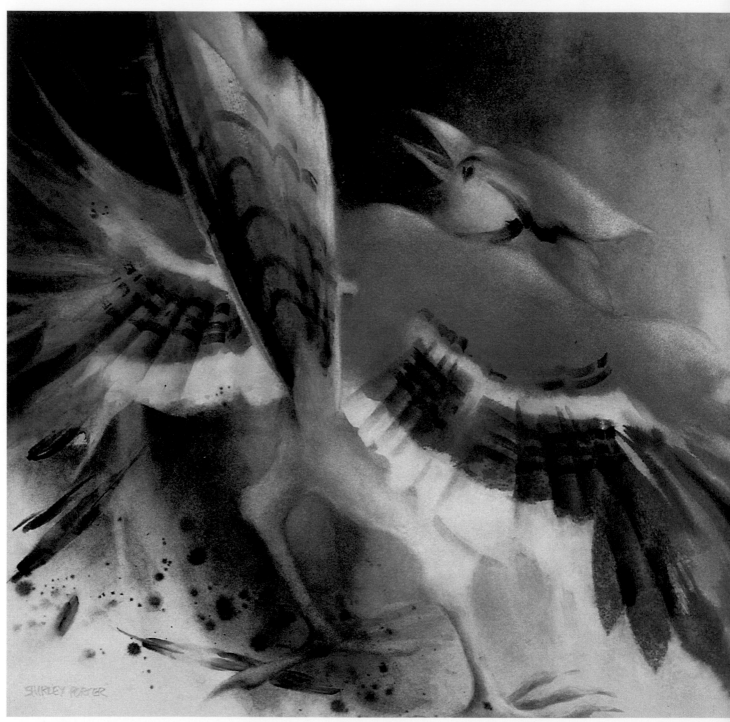

Tale of a Jay
28″×18″ (71cm×46cm)

PAINTING FAMILIAR ATTITUDES AND POSES

Birds have their own ways of behaving, and depicting these actions in your painting makes the finished piece even more birdlike. Birds aren't always stuck stiffly on a limb, totally in profile. Even when limb perching, they are constantly flitting, jumping, bending and stretching. Birds peck, fluff feathers, sit on nests, fly, preen and scratch in fallen leaves. They sing, tuck their heads, lift their tails, stand on one foot, swivel their heads—the list is endless. Birds are almost constantly active. And yet, when they choose, they can also be motionless!

Exercise One: Wood Thrush
Traditional Perching Pose

Viewing the bird from the side or partially facing the artist is a favorite approach for several reasons. It positions the bird so that most of the identifying features can be clearly seen. You can see the colors of both the wings and the chest, and because there's a lot of variety in the shapes from head to tail, it's easy to arrange these shapes into a good design.

Paper
Cold-pressed Arches
140 lb. (300gsm)

Palette
New Gamboge
Yellow Ochre
Alizarin Crimson
Hooker's Green
Permanent Blue
Raw Umber
Burnt Umber

Brushes
no. 7, no. 3, no. 0 round

Complete Drawing
Draw a wood thrush in pencil.

Step 1: Underpaint the Head and Body
Soak and drain your paper, and place it on your Masonite board. Use your no. 7 round to paint the head and body with Raw Umber. Don't paint quite to the edge to keep the color from spreading outside the bird. Save the eye marking by painting around it. Blot the top of the head and shoulder with a paper towel to highlight them. Darken the underside of the branch with another layer of Raw Umber.

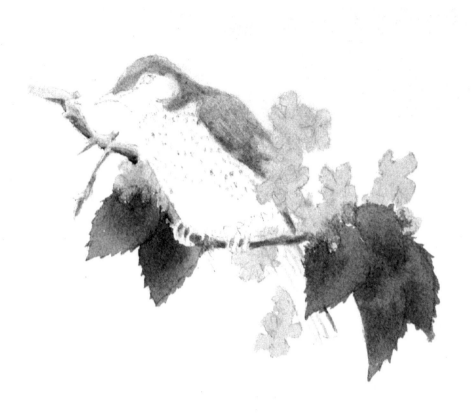

Step 2: Underpaint Blossoms and Leaves

Use a no. 7 round with a very thin mix of Alizarin Crimson and New Gamboge to color in the blossoms with a no. 7 round.

Mix Yellow Ochre and Hooker's Green and paint the leaves. Randomly add more Hooker's Green to the painted leaves to add color variety. Notice how the darker color flows when added to the still wet yellow-green.

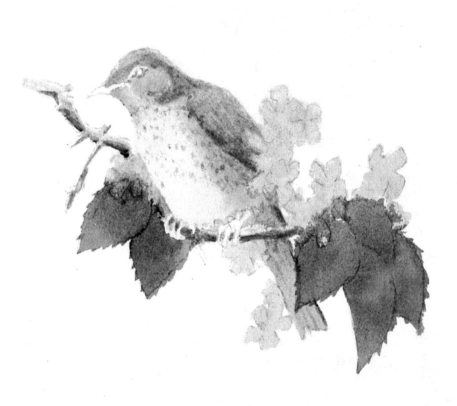

Step 3: Model the Breast

Mix a gray of Alizarin Crimson, Permanent Blue and New Gamboge and model the breast using a no. 7 round. The bird faces the light, so the area closest to the wing is darkest. Use more water as you move away from the wing. Paint the cheek with this same gray.

Step 4: Paint Large Details

Paint additional layers of your gray mix using a no. 3 round to separate the chest from the tail and to define the tail feathers. Paint the cheek pattern and darken under the chin with the same gray. Define individual blossoms with an Alizarin Crimson/Yellow Ochre mix. Soften the edge of the color by brushing it with clear water before it dries. To model the blossoms, dampen the center of each blossom and add additional layers of the same color mix. Separate the leaves with a Hooker's Green/Yellow Ochre mix. Soften the painted color with clear water.

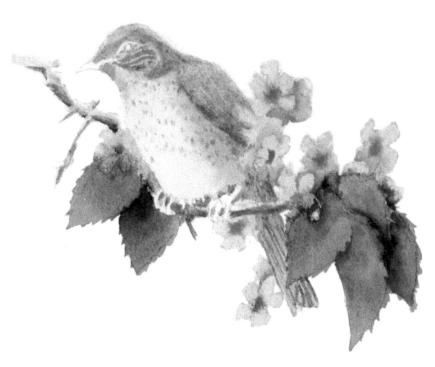

Step 5: Paint Small Details

Add fine lines to the branch using Burnt Umber and a no. 3 round. If your paper is almost dry, brush the chest with clear water and then paint spots of Burnt Umber. The damp paper will make the spots soft.

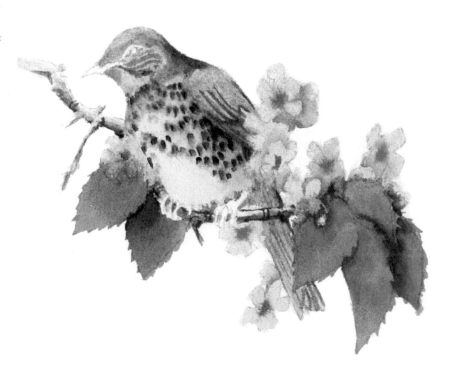

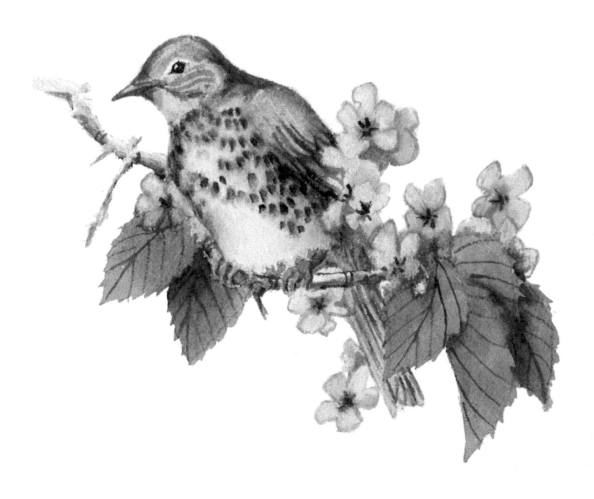

Step 6: Refine Small Details

Define some blossom edges with an Alizarin Crimson/New Gamboge mix and a no. 3 round. Paint Burnt Umber in the centers. Paint the leaf veins and blossom stems with Hooker's Green and Yellow Ochre. Define the edge of the head and back with Raw Umber. Use a no. 0 round to paint the eye with Burnt Umber, saving a highlight. The toes and beak are Alizarin Crimson and New Gamboge; darken the edges of each with gray to model them. Clamp the paper all the way around to a Masonite board so your painting dries flat.

Wood Thrush
12″×9″ (30cm×23cm)

Exercise Two: Eastern Bluebird
Unusual Perching Pose

Look for different ways to position your percher. An unusual pose is more interesting and more fun, too. This bluebird is posed rump first with one foot higher than the other.

Paper
Cold-pressed Arches
140 lb. (300gsm)

Palette
New Gamboge
Winsor Red
Cerulean Blue
Permanent Blue
Raw Umber

Brushes
no. 7, no. 3, no. 0 round

Complete Drawing
Draw a bluebird in pencil.

Step 2: Paint the Eye and Breast
Use a no. 0 round to paint the eye with a dark version of the gray mix from step 1. Save a highlight. Wet the breast with clear water and use a no. 3 round to paint it with an orange of Winsor Red and New Gamboge. Add orange to some of the branches to vary color.

Step 1: Underpaint
Mix a gray with New Gamboge, Winsor Red and Permanent Blue, and use a no. 7 round to paint the chest. Make the belly darkest to give form. Use a no. 3 round to paint the branches with Raw Umber.

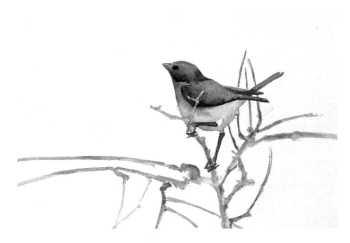

Step 3: Paint the Body
Use a no. 3 round to paint the head, wing, back and tail with Cerulean Blue. Use more color on the lower cheek, the back of the head and the wing edge. Use your no. 0 brush to paint the legs and beak with the dark gray mix from step 2. Save a highlight in the beak.

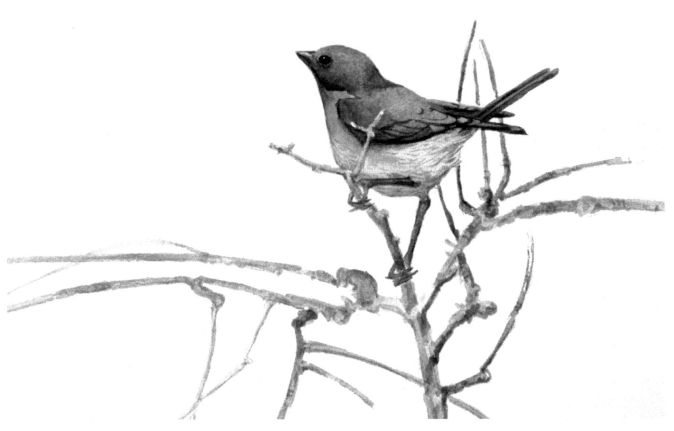

Step 4: Define Feathers and Model Branches
Use the gray from step 2 to define soft belly and rump feathers and to delineate wing feathers. Model branches with Cerulean Blue. Clamp the painting all the way around to the Masonite board so your painting dries flat.

Bluebird
12″×9″ (30cm×23cm)

Exercise Three: Cardinal (Female)
Nesting

I watched this cardinal build and tend her nest over a period of several weeks. When the last of her fledglings was gone, she left me with a beautiful nest, complete with a silver gum wrapper and some twine. Notice how the cardinal's body fits into the nest without spare room around her. This snug fit helps hold body heat against the incubating eggs. Her tail tips up to clear the back edge of the nest.

Complete Drawing
Draw a female cardinal in pencil.

Paper
Cold-pressed Arches
140 lb. (300gsm)

Palette
Alizarin Crimson
New Gamboge
Yellow Ochre
Winsor Red
Phthalo Green
Burnt Umber
Hooker's Green

Brushes
no. 7, no. 3, no. 0 round

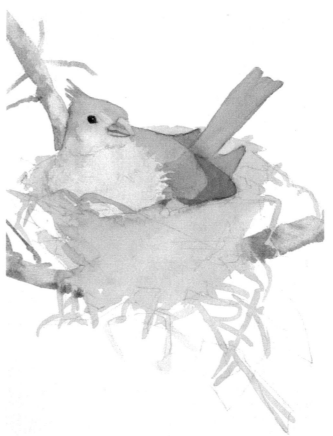

Step 1: Underpaint the Body *Detail*
Soak and drain your paper, and place it on your Masonite board. Drain the excess water. Using a no. 7 round, paint the breast area with a mix of New Gamboge and Yellow Ochre. Wash in the entire head and body with a mixture of Winsor Red and Phthalo Green. Use a no. 3 round to paint the beak with a Winsor Red/New Gamboge mix. An Alizarin Crimson/Phthalo Green mix painted with a no. 0 round gives a rich black for the eye.

Step 2: Underpaint the Nest
Wash in the nest and branches with a yellowish brown mixture of Yellow Ochre and Burnt Umber using a no. 7 round. Vary color from yellower to browner to give form.

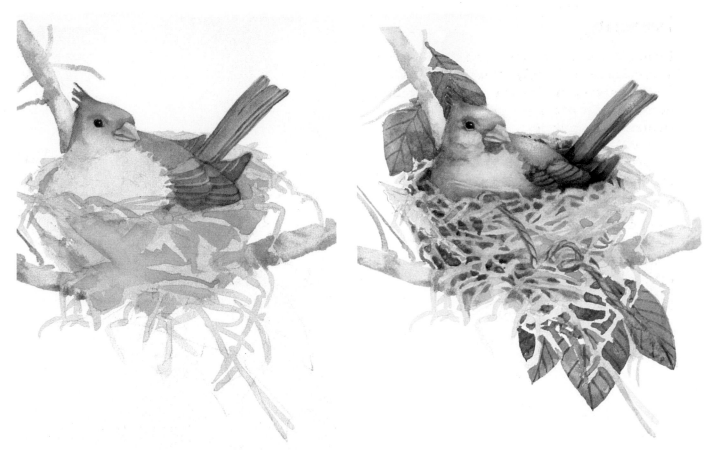

Step 3: Define Feathers

Suggest wing and body feathers using a no. 3 round with the gray mixture of Winsor Red and Phthalo Green from step 1. Add depth to the nest with more Yellow Ochre. Add gray to the back of the neck and to the head. Darken the Winsor Red on the head and tail.

Step 4: Add Details

Model the bird's body and the nest with darker mixtures of the color already used in each area. Using a no. 3 round, paint in leaves with a varied mix of Hooker's Green, Yellow Ochre and Winsor Red. Paint the veins with the same mix. Use Burnt Umber to paint the dark areas of the nest and the string.

Nesting Cardinal
12"×9" (30cm×23cm)

All Nests Are Not the Same

If you're painting a bird in a nest, make sure it's the right kind of nest for that bird. Some birds build nests on the ground or in low-growth such as reeds. Some birds use stones or clay to build their nests; others use twigs or grasses.

Exercise Four: Pigeons
Pecking

Pecking means heads down, tails up. Some birds do a lot of scratching, then do a quick peck before scratching some more. Others leave their heads down almost continually as they peck.

This painting shows several birds pecking, allowing us to arrange the birds into a pattern. Each individual pigeon is an oval, blobbish shape. Several awkward small shapes can be positioned to form a more interesting large shape.

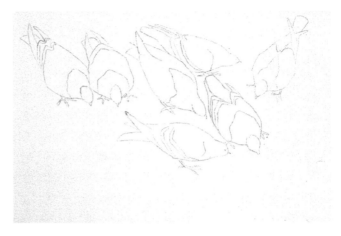

Complete Drawing
Draw a group of pecking pigeons in pencil.

Paper
Cold-pressed Arches
140 lb. (300gsm)

Palette
Alizarin Crimson
New Gamboge
Phthalo Blue
Phthalo Green
Raw Umber

Brushes
no. 3 round
Toothbrush

Step 1: Paint the Small Areas
Paint the smaller neck colors first so they don't get lost. Wet one neck at a time and use a no. 3 round to paint each in with Alizarin Crimson and Phthalo Green.

Step 2: Paint the Large Areas
Mix a light gray of Alizarin Crimson, Raw Umber and Phthalo Blue to paint the large body areas with a no. 3 round. Be careful to save the white wing areas.

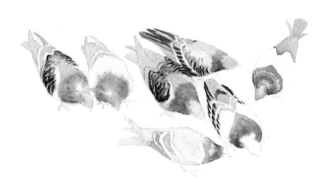

Step 3: Paint the Feather Patterns

Add Raw Umber to the gray mix of step 2 and paint feather patterns on four of the pigeons with a no. 3 round.

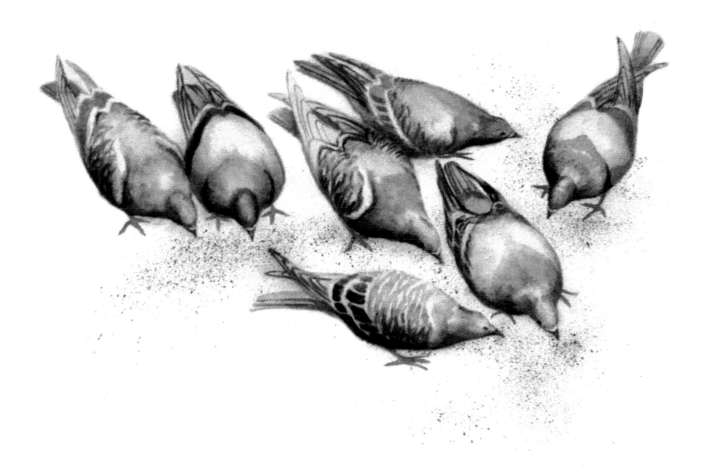

Step 4: Paint Details

Wet each body and use a diluted solution of the gray mix for the remaining feather patterns. Add more blue to model the wings, heads and bodies, using more gray at the edges. With clear water thin the gray away from the painted edge to soften it. Use the same gray and the no. 0 round to define more feathers. Mix Alizarin Crimson and Raw Umber together, and paint the beaks. Mix Raw Umber into the gray to paint the toes.

Using a toothbrush full of Raw Umber, spatter the ground area by dragging your thumb across the bristles. If you've never done this before, you may want to practice on a throw-away paper first.

Pecking Pigeons
12″×9″ (30cm×23cm)

Flying

A flying bird offers almost as many compositional possibilities as a grounded one because the wings, head and tail can be shown in a variety of ways. Wings can be fully extended, partially extended, up or down. A bird may be lifting off, landing, gliding or in full flight. Each variation of flying changes his silhouette.

SOME SHAPES OF FLYING BIRDS
Look for ways to break into the silhouette with "ins" and "outs," adding variety.

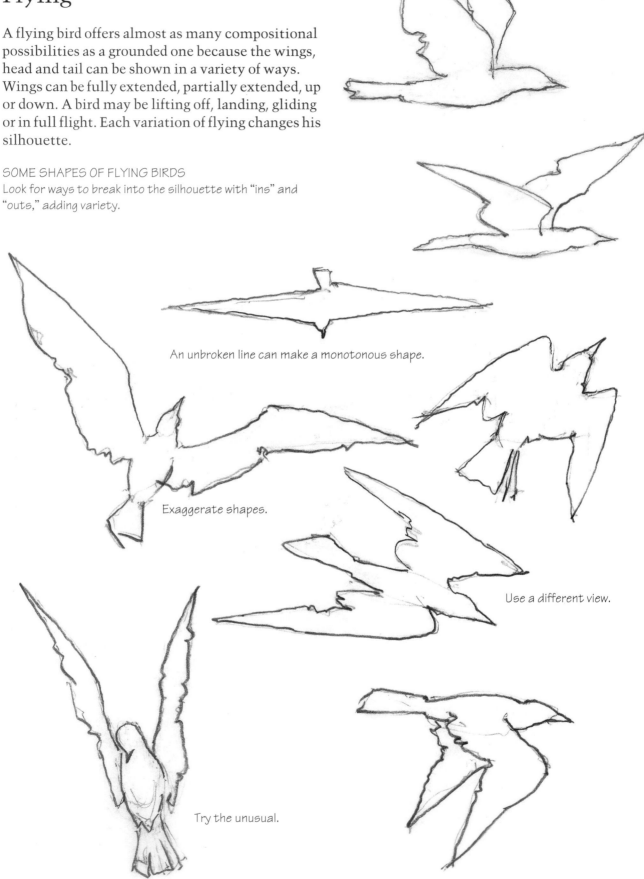

An unbroken line can make a monotonous shape.

Exaggerate shapes.

Use a different view.

Try the unusual.

SOME PLACEMENTS OF FLYING BIRDS

Placing a bird with outstretched wings in a composition can present design problems. The open wings make the shapes hard to fit in just anywhere.

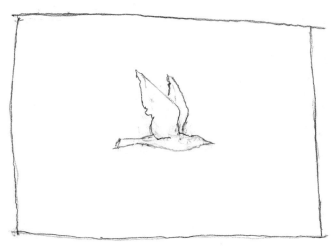

Central placement can be monotonous.

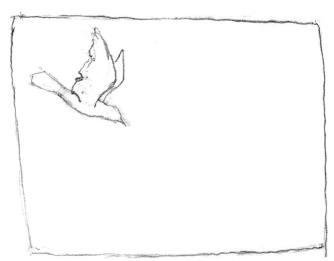

Place the bird at angles within the picture frame.

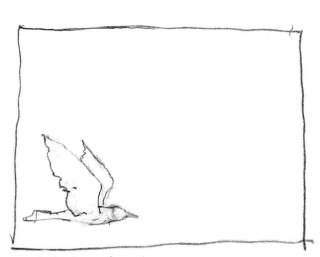

Move the bird away from the center.

Attach it to the edges.

Use most of the page.

Exercise Five: Red-Winged Blackbird
Full Flight

Begin this painting by deciding how much of the page you want the flying bird to occupy. Is the flying bird all the painting is about, or is he only a part of a bigger scene? What stage of flight is he in? Is he just beginning to lift into the air from a sitting or standing position? Is he in midflight? Gliding? Landing? These questions will help you decide the sizes of various picture components as well as their placement.

Complete Drawing
Draw a red-winged blackbird in pencil.

Step 1: Paint the Background
Mix a yellow-green of Hooker's Green and Yellow Ochre to underpaint the foliage with a no. 7 round. While the paper is still damp, add more green to the mix and add it randomly to the foliage to create some darker areas.

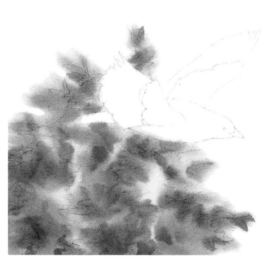

Step 2: Add Variety to the Foliage
Mix orange from Winsor Red and Yellow Ochre and add it randomly with a no. 7 round to the foliage. Begin suggesting some leaf shapes.

Paper
Cold-pressed Arches
140 lb. (300gsm)

Palette
New Gamboge
Yellow Ochre
Hooker's Green
Winsor Red
Permanent Blue

Brushes
no. 7, no. 3, no. 0 round

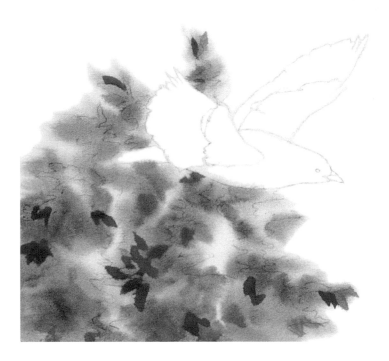

Step 3: Add Accents

Add more red to the orange mix and use a no. 7 round to paint a few red leaves for accent. Because the earlier colors have dried, these edges will be more defined.

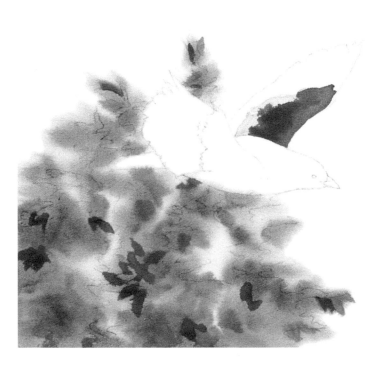

Step 4: Paint the Wing Design

Paint the yellow stripe of the bird with New Gamboge using a no. 3 round. Use your red-orange mix for the red wing design. Add more red to darken the area closest to the yellow stripe.

Step 5: Wash in the Body Color

Mix a warm black of New Gamboge, Winsor Red and Permanent Blue and underpaint the body and the far wing with a no. 7 round. Use a no. 3 round to paint around the eye to save an outline and highlight. Paint the underside of the closer wing with a lighter solution of the same black mix.

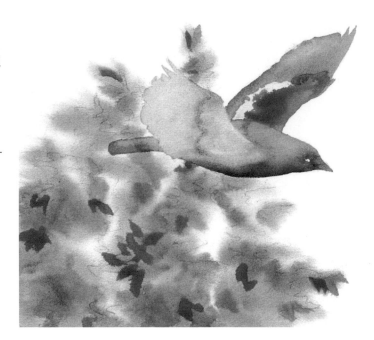

Step 6: Add Details

With a no. 3 round, darken the far wing by painting in feathers. Use the same black mix from step 5 with less water. Leave a highlight on the edge of each feather. Define feathers in the close wing and tail in the same way. Use your black to darken the area where the closer wing joins the body, and on the underneath side of the body and tail to model. Soften the edge of the added black area by painting it with clear water as it nears the top edge to create a highlight. Use your no. 0 round to paint the eye and detail the beak with black. Save highlights in the eye and beak.

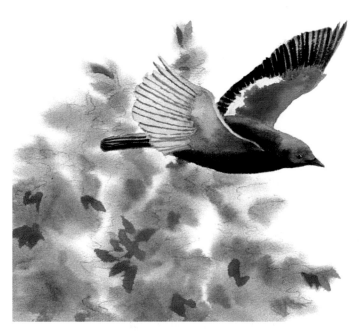

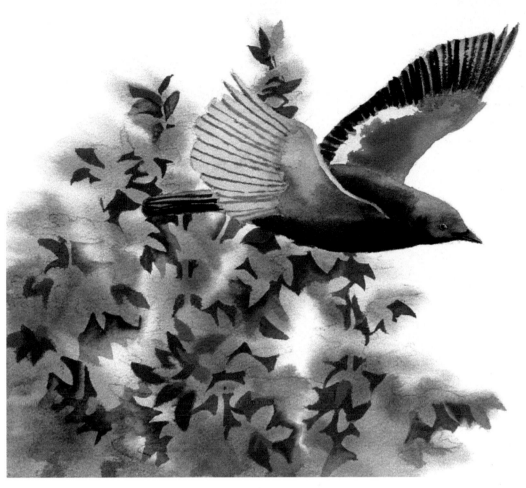

Step 7: Define Foliage

Mix a green of Hooker's Green and Yellow Ochre and describe leaves with a no. 3 round by *negative painting* (painting the space around the leaf). The result is a light leaf against a darker area. Soften the painted edges by painting them with clear water. Darken some of the red leaves for accent.

Red-Winged Blackbird
12″ × 9″ (30cm × 23cm)

Exercise Six: Common Yellowthroat
Lifting Off

In this demonstration, the bird is just leaving the branch. His wings are lifted all the way up and his toes point downward.

Complete Drawing

Draw a common yellowthroat in pencil.

Paper
Cold-pressed Arches
140 lb. (300gsm)

Palette
New Gamboge
Raw Umber
Yellow Ochre
Alizarin Crimson
Hooker's Green
Permanent Blue

Brushes
no. 7, no. 3, no. 0 round

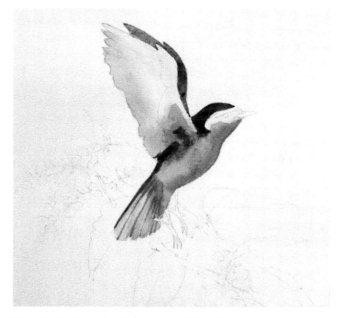

Step 1: Underpaint the Body
Mix a gray with Alizarin Crimson, New Gamboge and Permanent Blue and underpaint the entire bird using a no. 7 round, saving the white stripe and the eye. Make the belly, "armpit" and upper tail darker with additional layers of gray.

Step 2: Paint the Chest and Back
Wet the body and tail with clear water. Paint the chest, "armpit," and tail spot with New Gamboge using a no. 3 round. Paint the head, back and tail with Raw Umber. Use less paint as you near the belly. Blot a highlight on the head with a paper towel. Wet the tail and define feathers with Raw Umber and the gray mix from step 1.

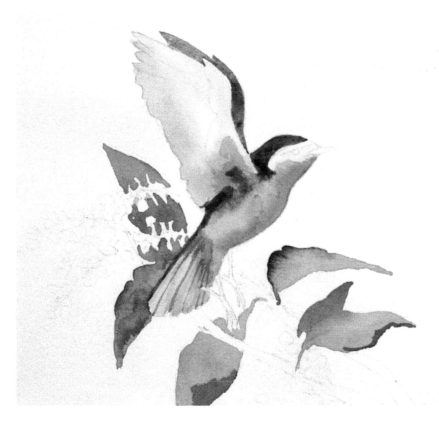

Step 3: Paint the Leaves

Mix a red of New Gamboge, Alizarin Crimson and Hooker's Green to paint the leaves with a no. 7 round. Use a redder mix in some areas for variety.

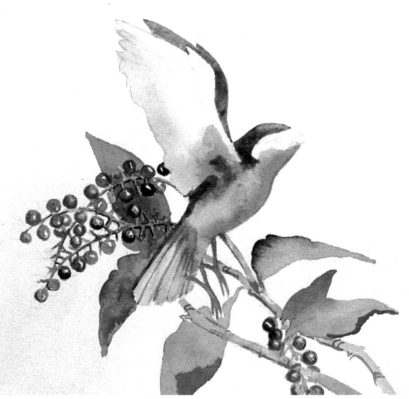

Step 4: Paint the Berries

Use the same red mix from step 3, adding even more red, to paint in the stems and some of the berries with your no. 3 round. Use a greener version of this mix for other berries. Leave a highlight in each berry. Use a no. 0 round to model the bottom edge of each berry.

Mix Yellow Ochre and Hooker's Green and paint the leaves and stem buds with the no. 3 round. Model the stems and legs with an Alizarin Crimson/Raw Umber mix.

Step 5: Paint the Face Pattern

Mix a black of Alizarin Crimson, Permanent Blue and New Gamboge. Wet the head with clear water and paint the black pattern with a no. 3 round, saving the eye. Use the no. 0 round to paint the eye black, saving a border and a highlight. Paint the beak with Yellow Ochre, then, when dry, with some gray mixture from step 1 to model. Using the no. 3 round, add modeling to the chest and belly, and darken the tail and legs with some thinned black. Use Raw Umber to define an edge to the white head strip.

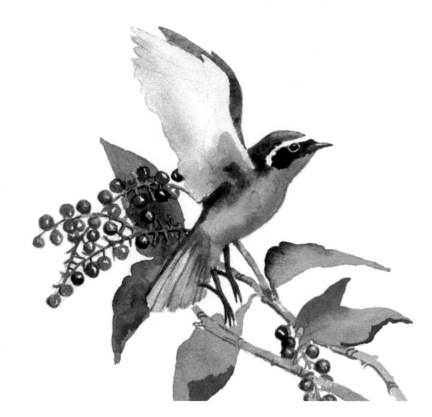

Step 6: Detail Feathers

Use the thinned black mix from step 5 to paint individual wing feathers and to separate the tail from the leg using the no. 3 round. Model the chest with a little Raw Umber. Use a dark mix of Hooker's Green, New Gamboge and Alizarin Crimson to detail the leaves.

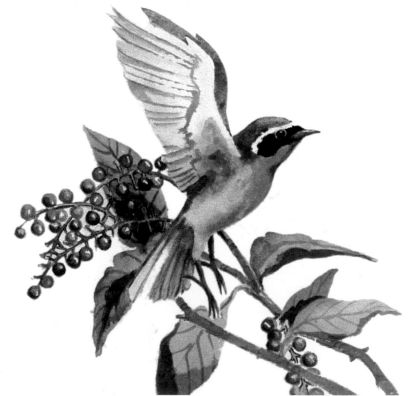

Common Yellowthroat
12" × 9" (30cm × 23cm)

Exercise Seven: Turkey Vultures
Flocks

A flock of flying birds can be arranged into an overall pattern, just as we did with the pecking pigeons. This is a very simple painting that can be done in two easy steps. The "fingers" at the wing tips are important because they help identify the bird from a great distance.

Paper
Cold-pressed Arches
140 lb. (300gsm)

Palette
New Gamboge
Winsor Red
Permanent Blue

Brushes
no. 3, no. 0 round

Step 1: Paint From Small to Large
Place your paper on your Masonite board, and pencil in the drawing of this flock of turkey vultures. Mix Winsor Red with a little New Gamboge and Permanent Blue to paint the heads using your no. 0 round.

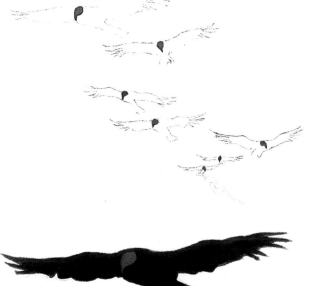

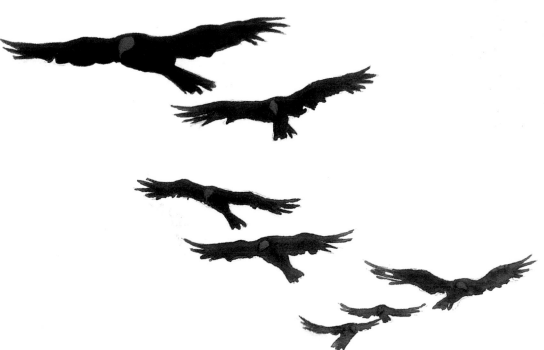

Step 2: Finish Birds
Use the same colors as step 1 to mix black for the rest of the birds, painting all but the wing tips with a no. 3 round. Paint the wing tips black using the no. 0 round.

Turkey Vultures
12″×9″ (30cm×23cm)

Exercise Eight: Mourning Dove
Ruffled Feathers

Birds aren't always smooth-feathered. They often fluff their feathers to groom or dry them. In winter, birds can be seen fluffing themselves, presumably for warmth. Fluffed feathers give the bird a very different silhouette.

This mourning dove just enjoyed a bath and is sitting with his feathers ruffled to dry them, resulting in a very different look than usual. In this demo you'll work on wet paper and lift color from painted areas to define the feathers.

Complete Drawing
Draw a mourning dove in pencil.

Step 1: Underpaint the Body
Soak and drain your paper, and place it on your Masonite board. Mix a gray from Burnt Umber and Permanent Blue and underpaint the entire bird using a ½-inch flat.

Paper
Cold-pressed Arches
140 lb. (300gsm)

Palette
Yellow Ochre
Alizarin Crimson
Cerulean Blue
Permanent Blue
Burnt Umber

Brushes
½-inch flat
no. 3, no. 0 round

Step 2: Paint Some Feathers
Darken the gray (less water) from step 1, and paint the face, part of the close wing, and some feathers on the far wing with the ½-inch flat. Apply additional layers of gray to darken the underside of the far wings.

Step 3: Add Color
Add Burnt Umber fairly heavily to the wing with the ½-inch flat.

Step 4: Lift Texture
Lift some of the Burnt Umber with the ½-inch flat to begin suggesting highlighted feathers. This must be done while the color is damp.

Step 5: Detail Feathers
Your paper should still be damp. Define some individual feathers of the body and wings with Burnt Umber and a no. 3 round. Smooth the edge of the added color with clear water.

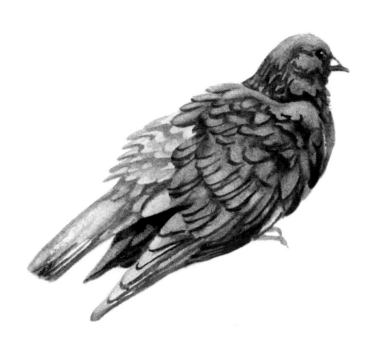

Mourning Dove
12″ × 9″ (30cm × 23cm)

Step 6: Paint the Head and Final Feathers
Mix Burnt Umber and Permanent Blue and paint the eye with your no. 0 round. Save a highlight. Paint the eye ring with Cerulean Blue. With the no. 3 round, darken the neck and define some feathers with Burnt Umber. Use the gray of step 2 on the beak and to de-lineate other feathers on the body and tail. Mix Yellow Ochre and Alizarin Crimson for the toes. Clamp your paper all the way around to your Masonite board so the painting dries flat.

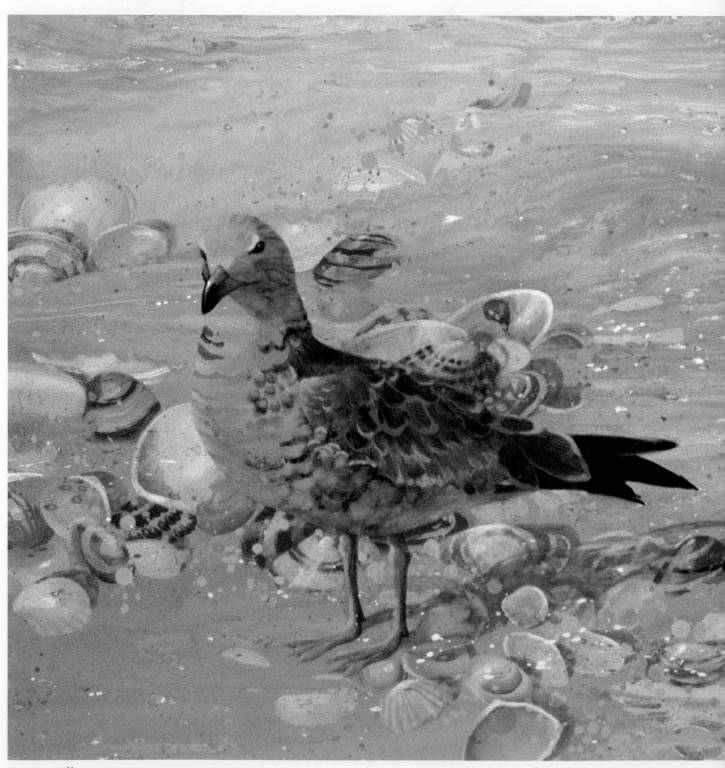

Young Gull
34″×24″ (86cm×61cm)

PAINTING BIRDS AND BACKGROUNDS

Backgrounds add information as well as beauty to your painting. They can show where a bird lives, how he lives and how this relates to his appearance. Seeing a heron standing in water tells us why he needs those long legs. But we wouldn't expect to see a goldfinch standing next to the heron in that lake. We would likely see the goldfinch perched on the center of a large sunflower. The nest a swallow builds and sits in is different from the haphazard one a barn owl makes. The perch a pelican prefers, an old log or pier, wouldn't suit a flamingo.

If you're painting a realistic background, you need to pay attention to the match between the bird and his background. A background can also be created from your imagination. In an imagined background, focus is on the colors and shapes around the bird and how they interact with those in the bird.

In the following demonstrations we'll explore several different treatments for backgrounds. We'll also compare two completely different directions resulting from painting different surroundings around the same image of a bird. Then we'll explore this idea further by using the same bird but changing our depiction of both the bird and his background from one painting to the next.

Exercise One: Spotted Sandpiper
Realistic Background—Middle Distance

Because this sandpiper is some distance from us, the area around him occupies much of the page and becomes an important part of the design. As much time will be spent on the background as on painting the bird.

Paper
Cold-pressed Arches
140 lb. (300gsm)

Palette
New Gamboge
Alizarin Crimson
Hooker's Green
Phthalo Blue
Burnt Umber

Brushes
no. 7, no. 3, no. 0 round

Complete Drawing
Draw a sandpiper in pencil.

Step 1: Underpaint With Yellow
Paint the grasses and leaves with a wash of New Gamboge using a no. 7 round.

Step 2: Develop Foliage

Mix New Gamboge with Hooker's Green and paint the foliage with a no. 7 round, leaving some yellow highlights. Underpaint the sandpiper's back with a wash of Burnt Umber.

Step 3: Detail the Foliage

Add Phthalo Blue to your green mix and paint shadowed areas on some of the foliage with a no. 3 round. Again, save some bright yellow highlights.

Step 4: Paint the Water
Mix Alizarin Crimson with
Phthalo Blue to paint the water.
Carefully paint around the bird
and small stems using a no. 3
round.

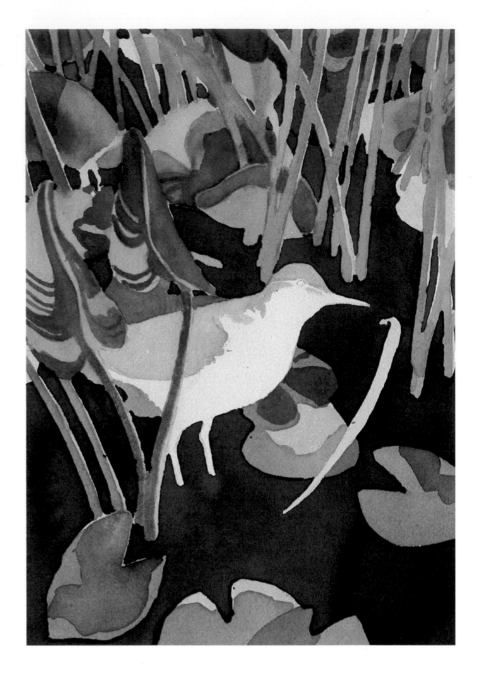

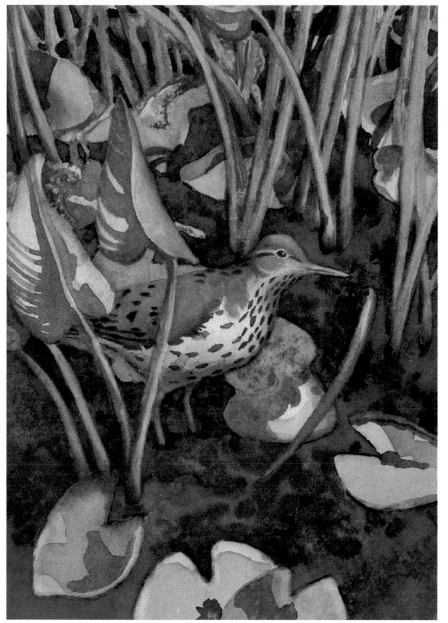

Step 5: Paint the Bird

Mix Burnt Umber with New Gamboge to paint the head, back and wings with a no. 3 round. Use Burnt Umber and a no. 0 round for the chest spots and eye and wing detail. Mix a gray with New Gamboge, Alizarin Crimson and Phthalo Blue to model the breast and legs. Paint some of the Burnt Umber/New Gamboge mix into the water and foliage for color variety and to tie the bird to the background.

Spotted Sandpiper
22″ × 15″ (56cm × 38cm)

Exercise Two: Cactus Wren

Realistic Background—Close-Up

This wren is very close so we can see the pattern in his wing and tail.

Paper
Cold-pressed Arches
140 lb. (300gsm)

Palette
New Gamboge
Hooker's Green
Cerulean Blue
Permanent Blue
Raw Umber
Burnt Umber
Winsor Red

Brushes
½-inch flat
no. 3, no. 0 round

Complete Drawing
Draw a cactus wren and cactus in pencil. Draw the cactus spikes in because they'll be light and you'll need to save them by painting around them.

Step 1: Underpaint the Large Areas
Use New Gamboge and a no. 3 round to paint the cactus. Save the white spikes and the wren's legs.

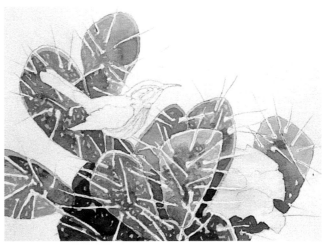

Step 2: Paint the Second Layer
Mix Hooker's Green with Winsor Red and give the cactus a light wash using a no. 3 round. Save the spikes and some of the bottom yellow layer of paint. Paint the cactus bloom with a thin layer of New Gamboge.

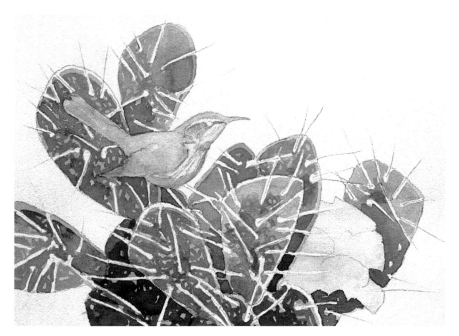

Step 3: Underpaint the Bird

Paint the bird's head, back, wing and tail with Raw Umber and a no. 3 round. Save the eye. Mix a gray of New Gamboge, Winsor Red and Permanent Blue and wash the breast. Use additional gray near the bottom edge of the breast to model it.

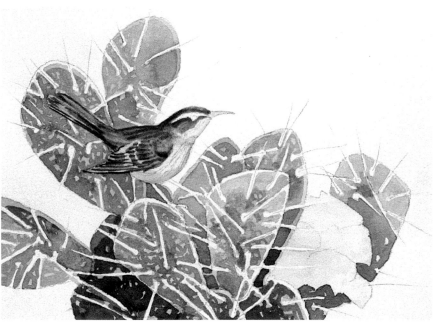

Step 4: Develop the Bird

Wash the bird's head, back, tail and wing with the gray of step 3. Add a soft Burnt Umber feather pattern to these areas with a no. 3 round while the gray is damp to get a soft edge. Save the lighter areas in the wing and tail by painting around them.

Step 5: Paint Small Details

Use Burnt Umber mixed with Permanent Blue to paint in the eye with a no. 0 round. Save a highlight in the eye. Paint the beak with the gray of step 3. Use more Winsor Red and New Gamboge in the gray mix to paint the legs. Wet the breast and add the spotted pattern with the Burnt Umber/Permanent Blue mix.

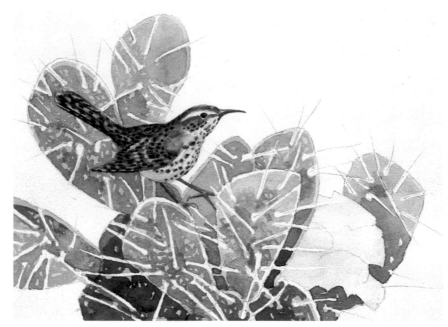

Step 6: Final Details

Use New Gamboge and a no. 3 round to define blossom petals. Soften each edge as you move up from the center. Add Winsor Red to New Gamboge in the bloom's center. Use the gray mix from step 3 to define the spikes against the white areas with a no. 0 round. Darken the mix to add shadows to the cactus. Put a New Gamboge highlight on the bird's head, wing and tail, and add additional gray to model as needed.

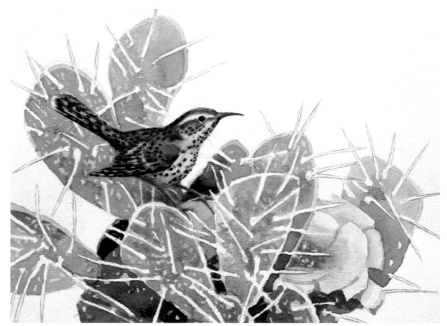

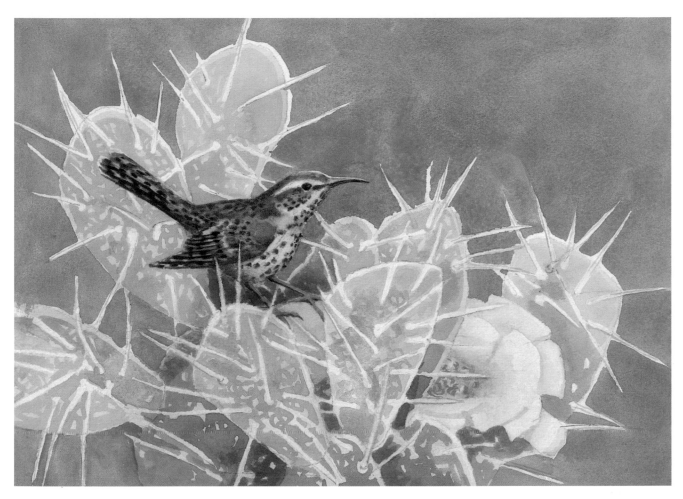

Step 7: Paint the Background

Use a ½-inch flat brush to paint the background with Cerulean Blue. Use a no. 3 round for areas close to the spikes.

Cactus Wren
12″×9″ (30cm × 23cm)

Exercise Three: American Redstart
Representational Background

This background has shapes that are identifiable as leaves and berries, but they are shaped loosely (as opposed to realistically). Use color freely in this painting.

Paper
Cold-pressed Arches
140 lb. (300gsm)

Palette
New Gamboge
Alizarin Crimson
Hooker's Green
Permanent Blue
Burnt Sienna
Burnt Umber

Brushes
½-inch flat
no. 7, no. 3, no. 0 round

Complete Drawing
Draw a redstart in pencil.

Step 1: Paint the Background
Mix New Gamboge, Alizarin Crimson and Permanent Blue to paint in a warm orange background with a ½-inch flat. Save the bird and branch so they don't get lost. Once this dries completely, add more Alizarin Crimson to the mix and paint in the bird's body and wing markings with a no. 0 round, adding New Gamboge in places for variety.

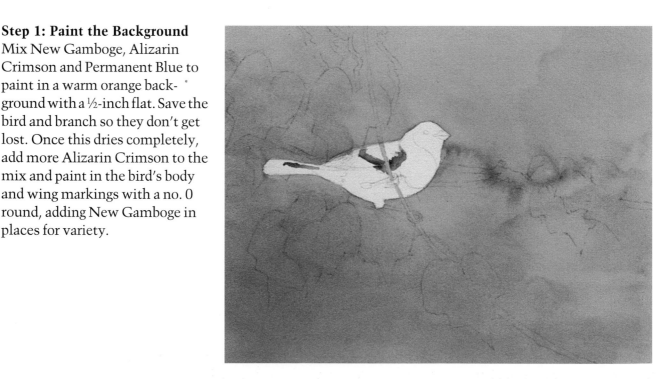

Step 2: Paint the Body

Mix black from New Gamboge, Alizarin Crimson and Permanent Blue. Use the black to paint the eye with a no. 0 round, saving a highlight. Use a no. 3 round to paint the body and tail black. Blot a highlight with a paper towel on the head, cheek and breast. You may choose to save a light eye ring, even though the redstart doesn't have one, so that the eye will be more visible.

Use a thinned gray version of the black mix for the underbelly. Use additional layers of gray on the bottom edge to model. Paint the legs with the black mix and a no. 0 round. Fill in the small orange area next to the leg with a no. 0 brush.

Step 3: Begin the Leaves

Mix a yellow-green from Hooker's Green, New Gamboge and Alizarin Crimson to paint the leaves with a no. 7 round. Mix a yellow-orange using the same three colors and add it to one of the leaves while the green color is still damp so that the colors will mix. Mix a redder orange from the same colors and add it and some Burnt Sienna to the damp leaf. Proceed from one leaf to the next while they're still damp.

Step 4: Paint the Branches and Berries

Use a no. 3 round to underpaint the branches with New Gamboge, then overpaint with your gray mix from step 2. Mix Alizarin Crimson with Permanent Blue and paint in the berries. Add new branches with Burnt Umber to fill in the design around the bird. Mix Burnt Sienna with Hooker's Green to detail the leaves.

Step 5: Final Details
Model the bird's underbelly with a no. 3 round and additional layers of gray. Paint in his beak with the black mix from step 2, leaving a highlight.

American Redstart
12″ × 9″ (30cm × 23cm)

Exercise Four: Blue Jay
Imagined Background

Backgrounds don't have to be realistic. Using colors and shapes to create an imagined design around the bird can result in an exciting painting. Try to repeat shapes and colors that you've already used in the bird. This will help unify the painting. Because the background and much of the bird come from your imagination, they can have any size, shape, color or placement you choose, so work freely with them.

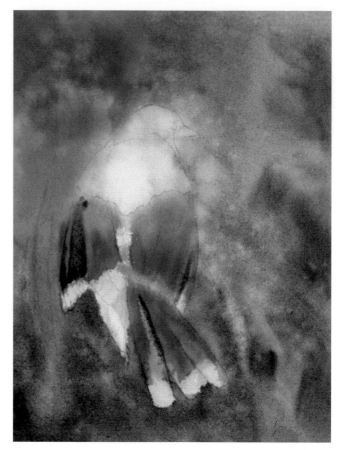

Complete Drawing
Draw a blue jay in an unusual pose. Crested birds such as the blue jay, cardinal and titmouse, don't always have their crests raised, giving them a different appearance.

Step 1: Lay Basic Colors
Soak and drain your paper, and place it on your Masonite board. While the paper is still very wet, use a ½-inch flat to paint in the background with Burnt Umber, Permanent Blue and a purple made of Permanent Blue and Alizarin Crimson. Let the colors flow together freely, forming new colors. Use Winsor Blue to paint in the bird's wings and tail. If too much color spreads into the white areas of the wings and tail tips, lift the still damp color with a clean, damp brush. Add Burnt Umber to parts of the wings and tail.

The light spots in the background are made by dropping water into the damp paint. Be careful not to overdo this.

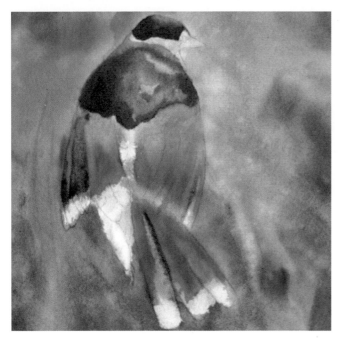

Step 2: Paint the Head and Back
Mix Permanent Blue with a little Alizarin Crimson to paint the jay's back and head with a no. 3 round. Save a highlight at the shoulder and the top of the head.

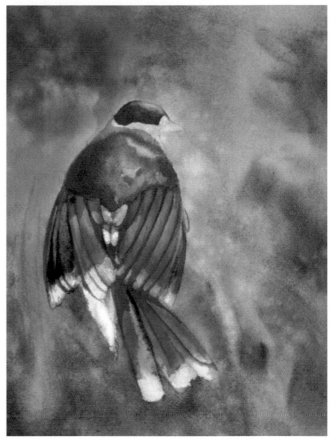

Step 3: Define Feathers
Use Phthalo Blue to define wing and tail feathers with a no. 3 round.

Paper
Cold-pressed Arches
140 lb. (300gsm)

Palette
Alizarin Crimson
Permanent Blue
Phthalo Blue
Burnt Umber
Winsor Blue

Brushes
½-inch flat
no. 7, no. 3, no. 0 round

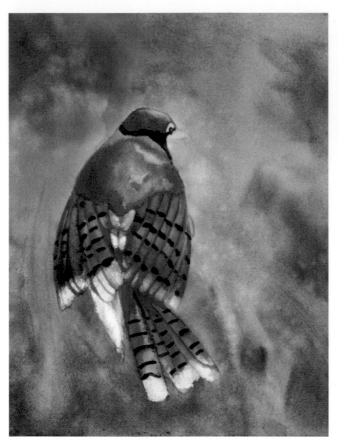 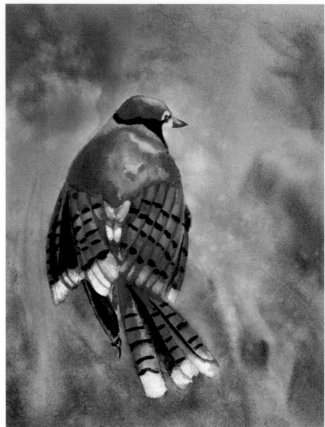

Step 4: Add the Feather Pattern

Mix a black from Permanent Blue, Alizarin Crimson and Burnt Umber and paint the feather and tail design with a no. 3 round. Notice that the black bands don't go straight across, but curve around the body. Do the same to the face pattern. Use the no. 0 round to paint the eye with this black, saving a highlight.

Step 5: Add Details

Add Burnt Umber to some of the feathers with a no. 3 round for color variety. Paint the leg, toe and beak gray (diluted black from step 4). Save a highlight on the beak.

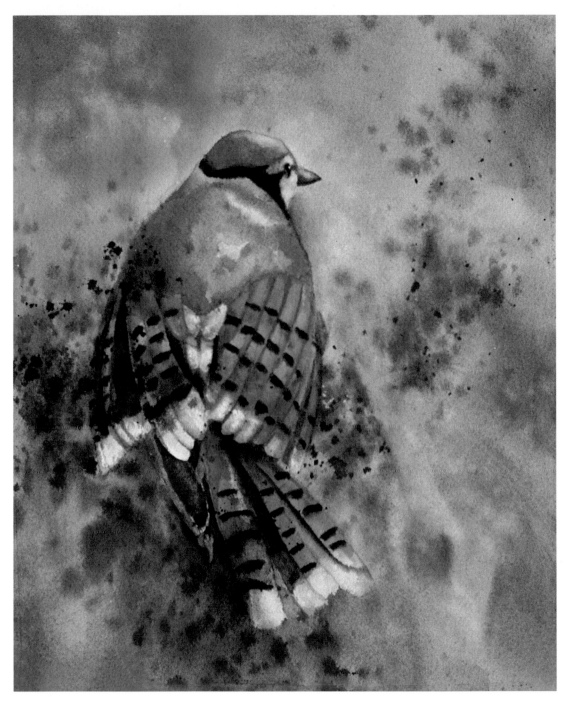

Step 6: Add Texture

This texture adds interest and helps unite the bird with the background. Drop the purple mix of step 1 and Burnt Umber into the damp paint with your no. 7 round. You'll get soft spots if your paper is damp. If it's too dry, rewet it first with clear water.

If you want more white showing in the feather tips, dampen them and gently scrub to loosen some of the color and blot it up with a paper towel. With the no. 3 round and Phthalo Blue, define some feather edges. Remember, your goal here is not realism.

Blue Jay
12″×9″ (30cm×23cm)

Exercise Five: Goldfinch
Two Different Directions

This demonstration takes us through parallel stages of two different paintings. In the first, the goldfinch sits in a typical background of realistically painted thistles. Even though the thistles are painted realistically, colors flow freely. In the second, the bird perches on a realistic branch, but the rest of the composition is treated in a decorative manner. The finches themselves are painted identically.

Allow your imagination to enter freely into your paintings. A good way to start is to take a painting you've done in a traditional or very realistic way and repaint it in a style dictated solely by your imagination.

Paper
Cold-pressed Arches
140 lb. (300gsm)

Palette
New Gamboge
Yellow Ochre
Alizarin Crimson
Hooker's Green
Phthalo Blue
Burnt Umber

Brushes
no. 7, no. 3, no. 0 round

Complete Drawing
This drawing shows the finch perched on a detailed thistle branch. Complete the drawing, and place it on your Masonite board.

Complete Drawing
Draw this goldfinch on a simple branch. Draw a border around the edge. When done, place the drawing on your Masonite board.

Step 1: Paint the Body

Mix New Gamboge with Yellow Ochre to paint the head and body of the bird with a no. 3 round. Use additional layers of Yellow Ochre on the breast to model it. Paint the beak with a Yellow Ochre/Alizarin Crimson mix. Mix New Gamboge, Alizarin Crimson and Phthalo Blue to make black and paint the eye, using a no. 0 round. Save a highlight in the eye.

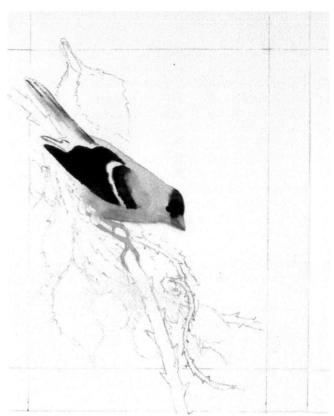

Step 2: Paint the Wing and Head

Use the black mix of step 1 to paint the wing and head patch with a no. 7 round. Dilute this black for the gray tail. Use a no. 0 round to paint the legs with Yellow Ochre.

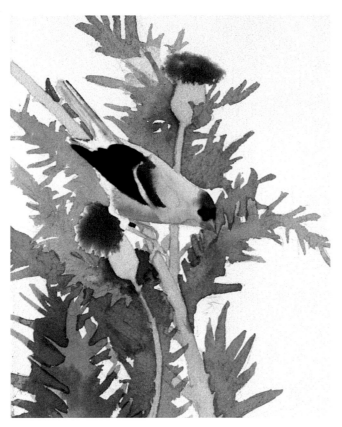

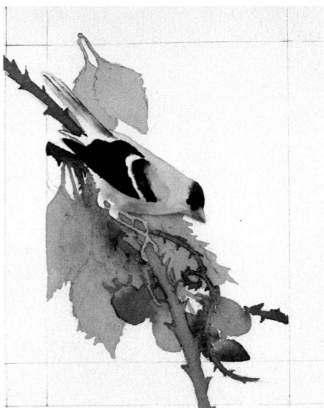

Step 3: Paint the Foliage

Now the two paintings begin to take separate directions. Use Yellow Ochre mixed with Burnt Umber to paint the close stem and bud with a no. 7 round. Use the same mix with more Burnt Umber on other leaves. Mix a purple from Alizarin Crimson and Phthalo Blue and drop the color into the still-damp leaves. Mix Hooker's Green with Yellow Ochre for the remaining leaves. Use the purple on the blooms.

Step 3a: Paint the Foliage

Mix Yellow Ochre with Hooker's Green and paint the leaves with a no. 7 round. Paint the stem with Burnt Umber mixed with Phthalo Blue using a no. 3 round. Use the purple mix from step 3 to underpaint the berries.

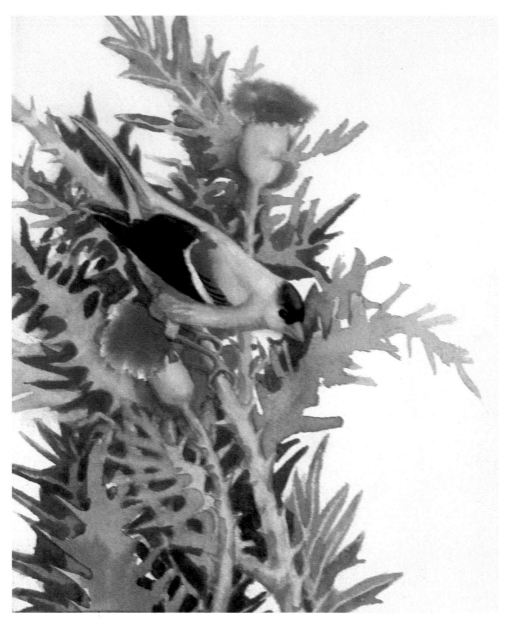

Step 4: Add Details
Use the same green mix of step 3 with more Hooker's
Green to darken some of the foliage using a no. 3
round. Use Burnt Umber mixed with Yellow Ochre
to model the bird's belly, tail and legs and the yellow
stems. Lift out shapes if more thistles are needed.

Goldfinch With Thistle
12″×9″ (30cm×23cm)

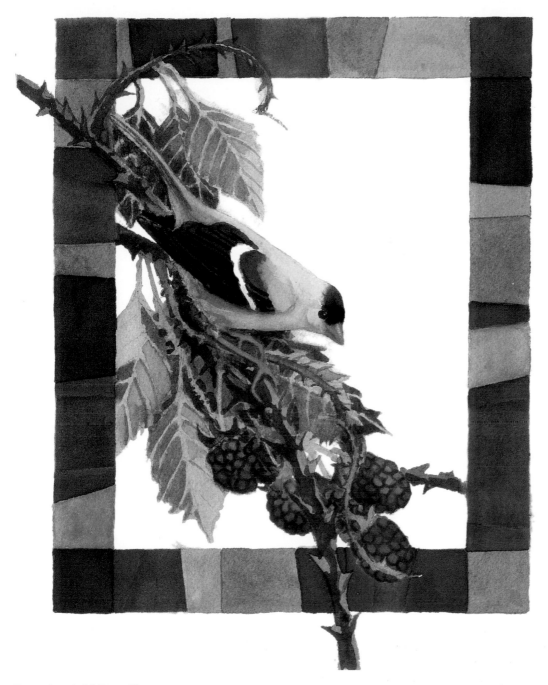

Step 4a: Add Details

Mix Hooker's Green, Yellow Ochre and Burnt Umber to detail the leaves. The light leaf details are formed by painting the darker color around them with a no. 3 round. Mix Burnt Umber and Hooker's Green to model the stem and the finch's leg. Mix Alizarin Crimson, Phthalo Blue and Yellow Ochre to detail the berries with a no. 0 round. Leave a highlight on each berry bump. Use the same colors found in the bird and foliage for the border. Place the colors randomly.

Goldfinch With Blackberries
12″×9″ (30cm×23cm)

Exercise Six: American Crow
Realistic Bird and Background

Complete Drawing
Draw a realistic crow and background in pencil.

The basic choices you make while you paint give you results that are totally different from one painting of a bird to another painting of the same bird. This demonstration takes us through painting a realistic bird with a realistic background.

For this crow painting, use a large sheet of paper, 15″ × 22″ (38cm × 56cm), to allow ample room for all the detailing on the bird.

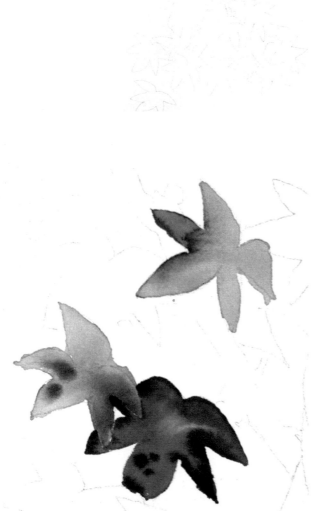

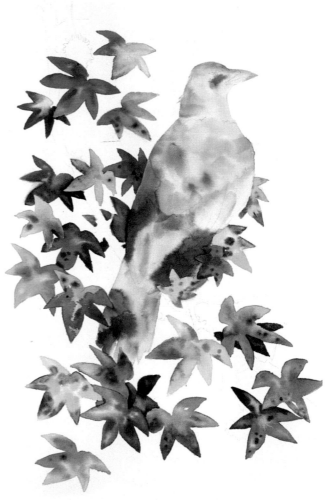

Step 1: Paint Leaves
Wet one leaf at a time and paint it using two or more of the following colors: New Gamboge, Hooker's Green, Alizarin Crimson, a purple mixed from Alizarin Crimson and Permanent Blue and an orange mixed from Alizarin Crimson and New Gamboge. Add the colors with a no. 7 round while the leaf is still wet so they flow into each other.

Step 2: Underpaint the Bird
Wet the crow with clear water and add the leaf colors with a no. 7 round to his head, wing, back and tail. These colors will become highlights and reflections of the leaf color in the dark color of the crow.

Your paper will be a little wavy from being wet unevenly. Don't worry, you can flatten it when the painting's finished.

Paper
Cold-pressed Arches
140 lb. (300gsm)

Palette
New Gamboge
Alizarin Crimson
Permanent Blue
Hooker's Green
Burnt Umber

Brushes
no. 7, no. 3, no. 0 round

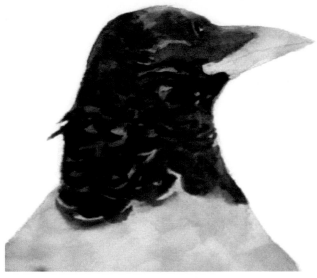

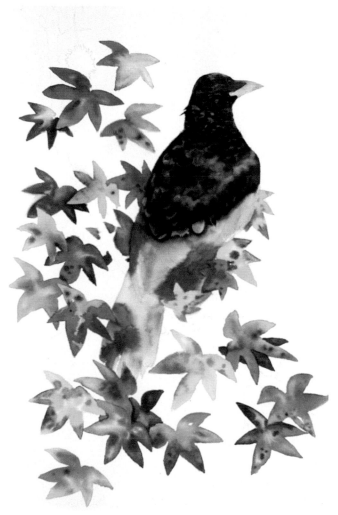

Step 3: Add Dark Colors
Wet the head with clear water. Mix a black from New Gamboge, Permanent Blue and Alizarin Crimson. Blot the eye fairly dry with a paper towel and paint it black using a no. 0 round. Save a highlight. With a no. 7 round, add a mix of Burnt Umber and black to the lightest areas of the head and cheek. Mix Permanent Blue and black and use this along with black in the darkest areas of the head. Save some underpainting for highlights and reflections.

Step 4: Paint the Crow's Back
Repeat what you did in step 3 on the rest of the crow, beginning with the bird's back. Wet the back using the same colors as before and work from light (Burnt Umber) to dark (black). The feather pattern builds into a V shape. Remember to save areas of the underpainting.

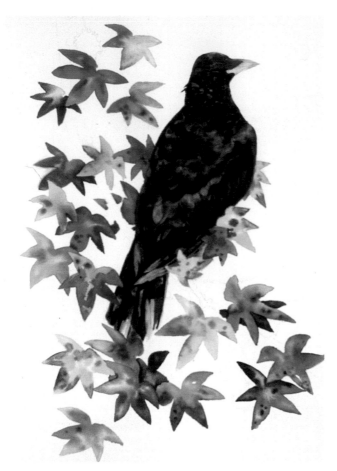

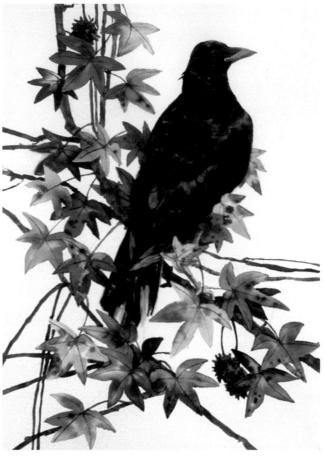

Step 5: Paint the Wings and Tail

Wet the wings with clear water and paint them the same way as you painted the back and head in step 4, using the same colors and brushes. Save some of the underpainting for highlights and reflections.

When the wings are completed, use the same procedure and colors to paint the tail.

Step 6: Paint Small Areas

Use a thinned version of the black mix from step 3 to paint the beak and leg. Leave a highlight on each. Use a no. 3 round to paint the seed balls with New Gamboge and Burnt Umber. Paint the large branch and add some smaller branches, both with Burnt Umber. Use a no. 0 round to paint some leaf stems in Burnt Umber. Add detail to the seed balls with additional layers of Burnt Umber.

Step 7: Complete the Background

Mix a dull green from Hooker's Green, New Gamboge and Alizarin Crimson. Paint a small area of the background with this color using a no. 7 round. While this color is still damp, add New Gamboge, Alizarin Crimson, purple or orange around it to suggest more leaves.

When the background is complete, let the painting dry completely. Then spray the back of the painting with water, let it expand, and clamp it on your Masonite board to dry flat. Be sure to place your clamps shoulder to shoulder.

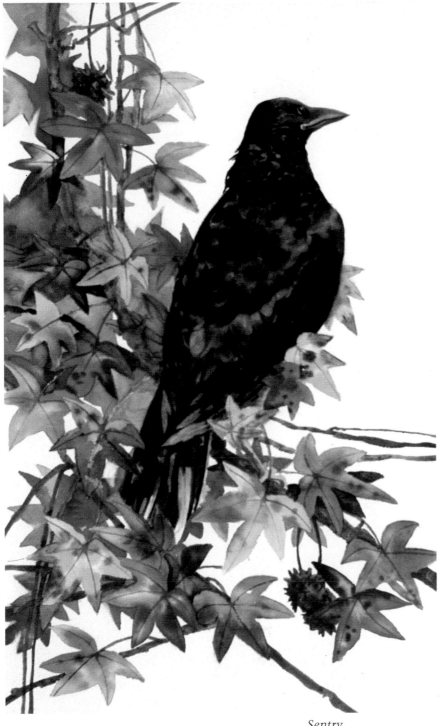

Sentry
22″ × 15″ (56cm × 38cm)

Exercise Seven: American Crow
Imagined Bird and Background

Once you've completed Exercise Six (pages 118–121) and have painted a realistic crow with a realistic background, try painting the same bird from your imagination.

Creating a painting from your imagination can take you into a totally new direction, opening up new ideas and approaches to your subject and to watercolor painting. Imagined paintings can be a little tricky to do because there's no logical procedure to follow as you work. Each one is different. But they make up for it by being so much fun!

As in Exercise Six, use a large sheet of paper, 15" × 22" (38cm × 56cm), to allow ample room for all the detailing on the bird and his surroundings.

Paper
Cold-pressed Arches
140 lb. (300gsm)

Palette
Raw Sienna
Alizarin Crimson
Antwerp Blue
Burnt Umber

Brushes
½-inch flat
no. 7, no. 3, no. 0 round

Complete Drawing
Make this drawing of an imagined crow a little darker than usual as you'll be running paint right across the drawing, and you don't want it to get lost.

Step 1: Painting Flowing Colors

Soak and drain your paper, and place it on your Masonite board. While the paper is still very wet, brush on Raw Sienna, Alizarin Crimson, Burnt Umber and Antwerp Blue with a ½-inch flat. A lot of color will be added in this first step. The reason is that you want all the areas of color to flow together over the entire painting, so this first layer must all be painted *while the paper and each added color are wet.* Paint the highlighted areas (top of the head, back, edge of the tail and edge of the wing) with Raw Sienna. Use Raw Sienna behind the crow's head so that the final black color of the head will contrast sharply against the background.

Paint Antwerp Blue in some of the background areas.

Mix a purple from Antwerp Blue and Alizarin Crimson and add to the background and underbelly of the crow.

Finally, use Burnt Umber to suggest some feathers. Spatter Burnt Umber and Raw Sienna into the background to balance the color and add texture. Dry the painting thoroughly.

Step 2: Rewet the Painting

Turn the painting face down and, using a sprayer filled with water, thoroughly spray the back of the paper. Place the painting face up on your Masonite board, and gently spray the front completely. When the painting is completely wet again you'll be able to get more soft edges as you continue to work. The entire painting will be done on very wet to gradually damp paper. Anytime your painting begins to get too dry, gently spray the surface.

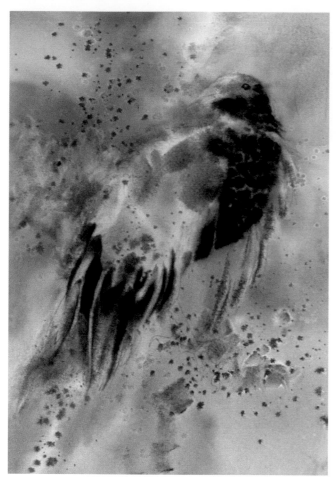 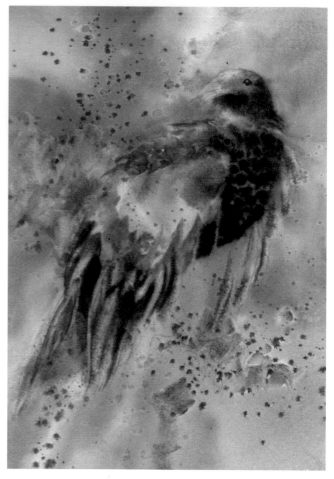

Step 3: Begin the Bird

When you're doing a very free painting, it's not important that each of your colors falls exactly where mine do. It's the effect you're after, not duplication.

Mix a black from Raw Sienna, Alizarin Crimson and Antwerp Blue and paint the eye using a no. 0 round. Save a highlight. Use the corner of a ½-inch flat to suggest feathers on the chest, throat and wing with the black. Leave some of the underpainting showing through to give a feather texture. Don't paint right up to the edge of your drawing or the paint will flow beyond your outline.

Step 4: Add Brown Feathers

Use Burnt Umber to paint some feathers in the back and wing with a ½-inch flat. Soften the painted edge so it blends into surrounding areas. Use your purple mix of step 1 for the back wing feathers. Make them long and exaggerated to suggest a cloak around the crow's shoulders. If you have trouble with the ½-inch flat here, use a no. 7 round. Paint around the legs and feet with purple to help unify the color design.

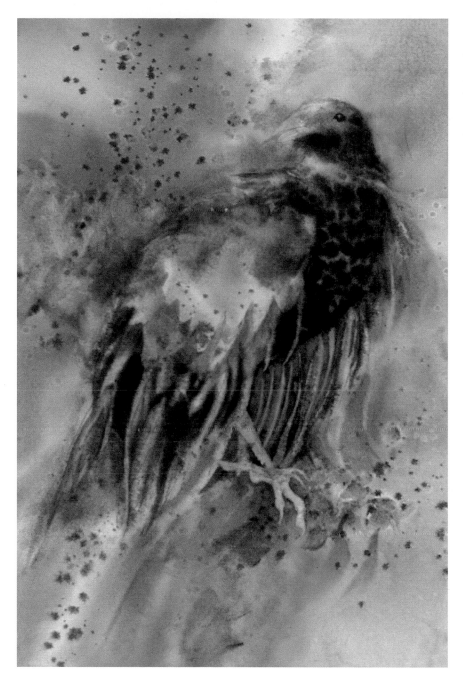

Step 5: Unify With Feather Shapes

With a ½-inch flat, add more feather shapes around the crow with the purple from step 1 and some Antwerp Blue. Use a no. 7 round to lift any dark areas from the toes and legs so they can be seen against the surrounding areas.

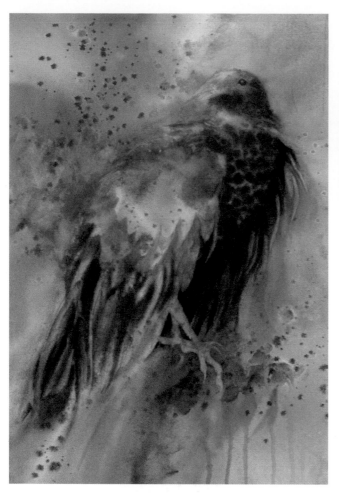

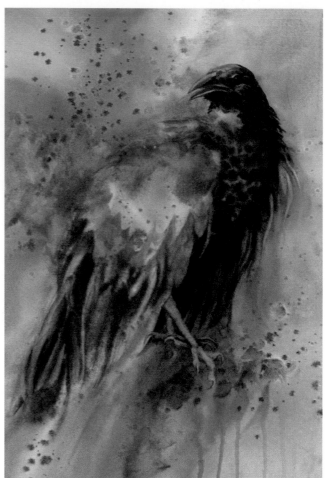

Step 6: Add Detail to the Wings
Add darker purple (more blue, less water) to the back wing with a ½-inch flat. The drips on the lower right are created by tipping the painting board up while the paint's still wet. Add the black mix from step 3 to the back wing close to the body as shadow. Use the edge of your flat brush to lift still-damp color, forming some light details in the wings.

Step 7: Detail the Head and Feet
Use Alizarin Crimson to paint the inside of the mouth with a no. 3 round. This color change makes the mouth more dramatic. Add more feathers to the head and darken the eye with the black from step 3. Paint the legs and feet with a thinned black. Add additional layers of this gray to model.

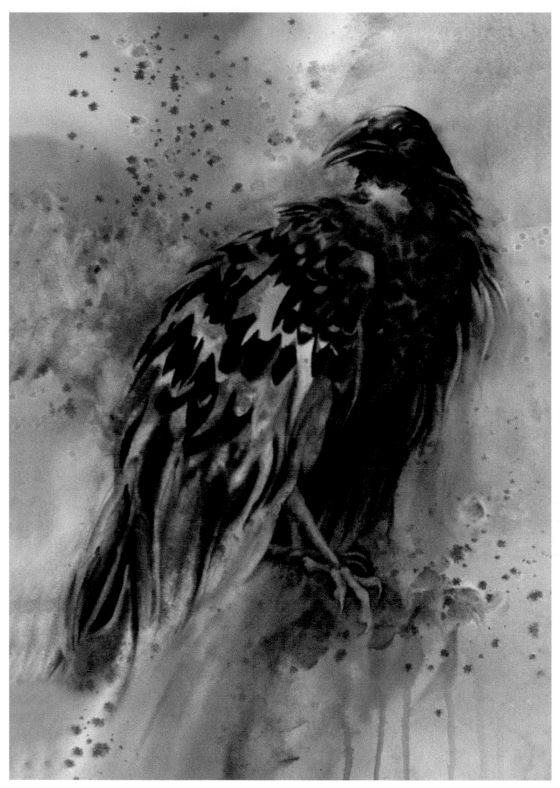

Step 8: Finish the Wing
Use black to add feather shapes to the large wing in the front with a ½-inch flat. Clamp the painting all the way around to your Masonite board and let it dry flat.

King Crow
22″ × 15″ (56cm × 38cm)

INDEX